Mastering the Craft of Painting

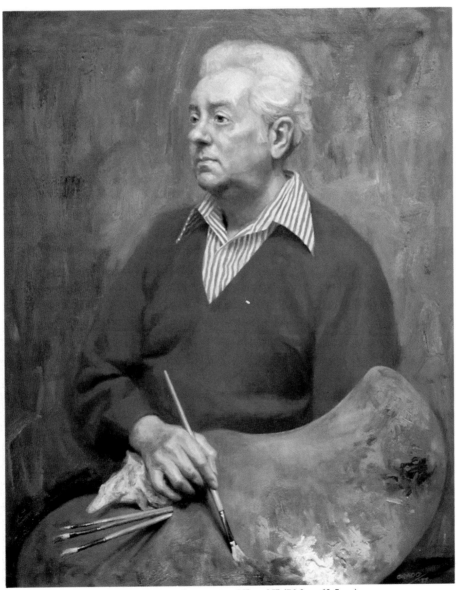

Andrea Cella, *oil on canvas, 30" × 25" (76.2 × 63.5 cm)*

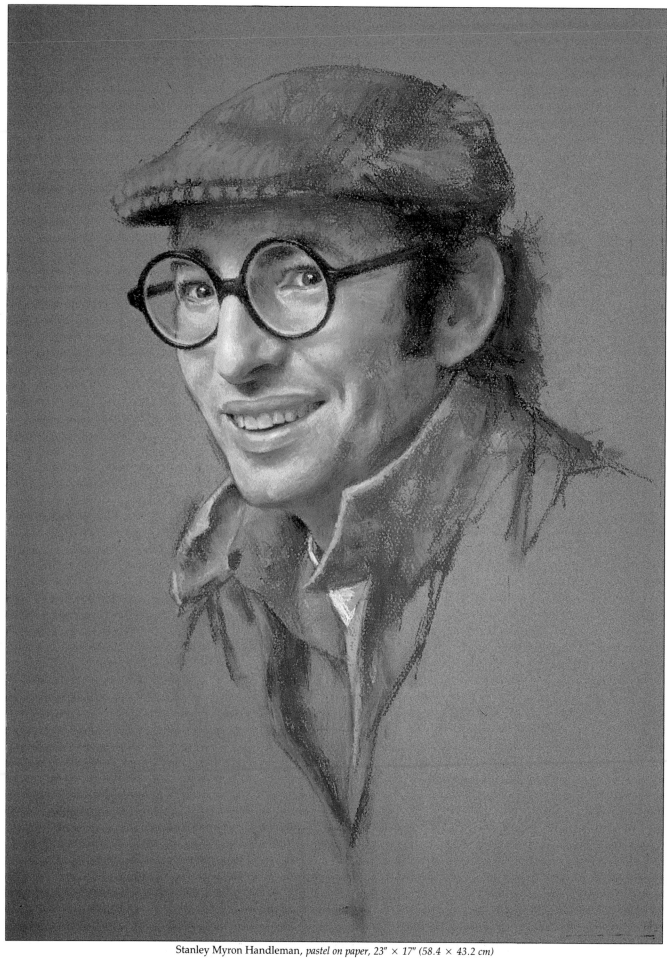

Stanley Myron Handleman, *pastel on paper, 23" × 17" (58.4 × 43.2 cm)*

Mastering the Craft of Painting

BY ANGELO JOHN GRADO

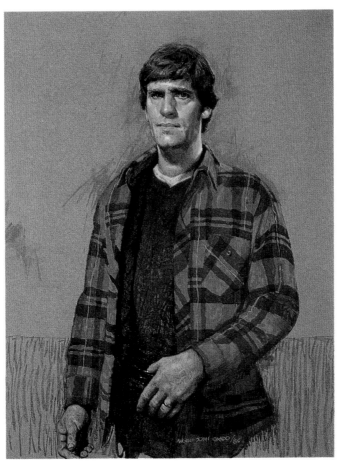

Portrait of Jack, *pastel, oil, and watercolor on paper, 40" × 30"*
(101.6 × 76.2 cm), collection of Mr. and Mrs. John R. Dick

WATSON-GUPTILL PUBLICATIONS/NEW YORK

Special acknowledgment and thanks to:

My mother and father, Rose and Pasquale Grado, who are responsible for my being here. My late Uncle John, for taking me to my first museum and encouraging me as a child; Uncle Fred Polizzi, who is always ready to pose; and my son John, who always makes things easier for me. To my daughter Barbara and her husband Richard Devir, my son Paul and his wife Janet, my son Frank and his wife Kathy, my youngest son Richard, and my grandchildren Paul, Nanette, Megan, Kate, Stevan, Della, K.C., and Justin. My special thanks to Andrea and Grace Cella, Peter Matulavage, and last but not least, to Mary Galletti, who is always ready to help in any way needed.

First published in 1985 in New York by Watson-Guptill Publications, a division of Billboard Publications, Inc., 1515 Broadway, New York, N.Y. 10036

Library of Congress Cataloging in Publication Data

Grado, Angelo John, 1922–
 Mastering the craft of painting.

 Includes index.
 1. Painting—Technique. I. Title.
ND1500.G65 1985 751.4 85-13724
ISBN 0-8230-3016-4

Distributed in the United Kingdom by Phaidon Press Ltd., Littlegate House, St. Ebbe's St., Oxford

Manufactured in Japan

First printing, 1985

1 2 3 4 5 6 7 8 9 10/90 89 88 87 86 85

This book is dedicated to my wife
Justine
for her love and patience

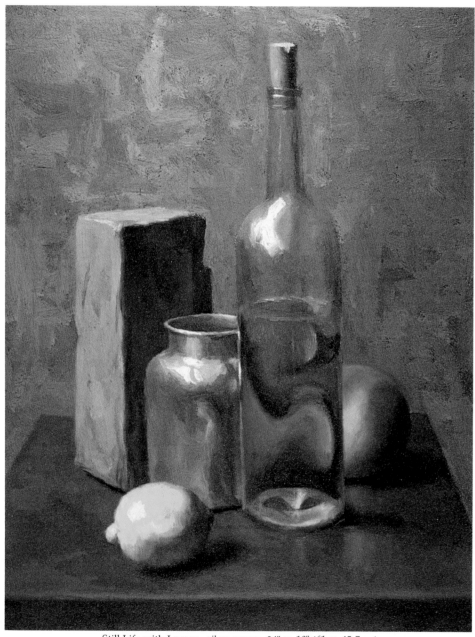

Still Life with Lemon, *oil on canvas, 24″ × 18″ (61 × 45.7 cm)*

Contents

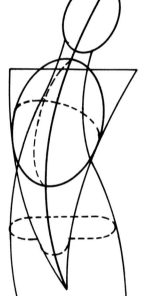

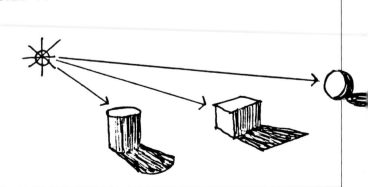

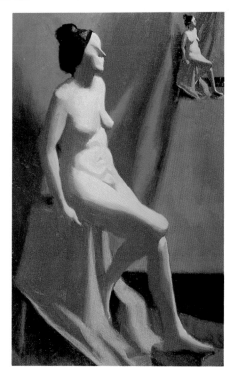

BEYOND THE LESSONS: DEVELOPING YOUR INDIVIDUALITY 106

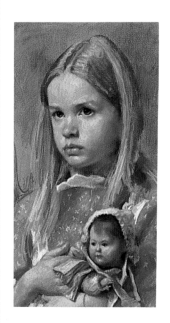

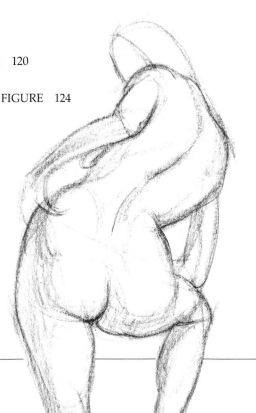

Introduction

The most difficult problem faced by art students has always been to find a teacher who knows how to paint, who knows his or her craft, and who has the teaching talent to impart this knowledge to students. It is also extremely important that the teacher's knowledge is passed on without the student becoming a carbon copy of the teacher.

Frank J. Reilly, who taught at the Art Students League in New York City and eventually established his own art school, was a teacher who had all these qualities. His students were taught the *craft* of painting and picture making, not just one teacher's personal method, as is so often the case.

In viewing paintings at various art exhibitions, I usually find it easy to see who studied with whom. But I find it difficult to pick out which painters studied with Frank Reilly. To this day, I don't know of a single former student who paints using Reilly's personal technique. Many professionals in the art field saw his teachings as too "mechanical" or "methodical," but I disagree. Learning the mechanics of art is as important to a student of art as learning the scales or correct placement of fingers is to a student of music. The craft of painting must be thoroughly and correctly learned for a student to develop complete control over the medium. Once this control is achieved, the student can choose whatever direction in painting suits his or her particular personality and temperament.

My own study of painting actually began with Robert Brackman, a very dominant, dynamic teacher at the Art Students League. I chose Brackman because I sincerely liked his paintings, and I still think his best paintings rank among the finest in America. His strong point in teaching was the "conception" of the painting. "Without a good conception, there can be no art to a picture," he would say, "no matter how well the painting is executed."

Brackman taught us to see in terms of color and relationships of one thing to another. But the first step was a good conception. If your conception was not to his satisfaction, you had to wash the canvas down with turpentine to the original white priming. After washing down several canvases, it's amazing how much time you'd spend making the next conception a good one. This is how to develop discipline.

The next step was to paint in the background, which would then be the key to the whole figure painting. When the background was correct to your and Brackman's satisfaction, you proceeded to paint in the shadow areas of the figure. These shadow areas had to be correctly related to the background. Sometimes a whole week would pass with only the background and the shadow areas containing paint. The light areas could not be painted until the shadows were in correct relation to the background.

After three years of study, and on Brackman's advice, I spent one year painting on my own. By the time the year was up, I knew I needed more

experience painting from the model and someone to help me on the next phase of my education.

Robert Brackman and Robert Philipp were good friends from their art school days, and Brackman always had the highest praise for Philipp's paintings. With this in mind, I enrolled in the National Academy Art School to study with Philipp, although not full-time. I worked with him for three months, alternating with three months by myself, for the next few years.

I found Philipp a much more emotional painter and a warmer person than Brackman. Given his emotional personality, he produced more uneven paintings than Brackman did, but the aesthetic highpoints were much greater—which, to me, is more exciting. He was not overly concerned with the conception or procedure, but rather with beautiful color and the application of pigment. He was truly an artist.

Even after studying with Philipp, however, I felt a lack in my craft. Brackman had given me a feeling for the conception, as well as for pastel, and Philipp taught me about the aesthetics of painting. But that certain control of the overall picture was still missing.

All during these painting years I continued freelancing in commercial art to support my wife and five children. One of my accounts was as art director of *Art Times* magazine, and through this I met Frank Reilly. We became good friends, and when he looked at some of my paintings, he astounded me with his knowledge of the craft of painting. He knew just where I went off (primarily in my values).

I enrolled in the Frank Reilly School of Art and the final part of my education began. At the time I was already a member of the American Watercolor Society, Salmagundi Club, and the American Artists Professional League. I was entering and being accepted in national exhibitions and winning awards. But I purposely entered the Frank Reilly School with the mental attitude of a beginner, wanting to learn everything he had to teach.

Reilly gave weekly lectures with home assignments. There was no phase of painting or drawing that was not covered, from the conception to the finish. We had assignments to make charts on everything, covering all the variations in value, hue, and chroma for landscapes and the human form. I think I spent one summer just mixing and tubing paint—yes, we pre-mixed and tubed most of our colors in Reilly's class. After all the colors were tubed, I made charts for every conceivable human complexion in nine values for every hue and chroma.

While I was in Reilly's class, he became ill, and he died in January 1967. In the following years, whenever I felt the need to work from the model, I enrolled in Robert Philipp's class at the Academy for a month or two. In 1972 I was awarded a bronze medal for a large oil of a nude that I painted in his class. From then on I painted on my own entirely, thankful to each of my three teachers. Each was different, and each certainly contributed to the quality of my paintings.

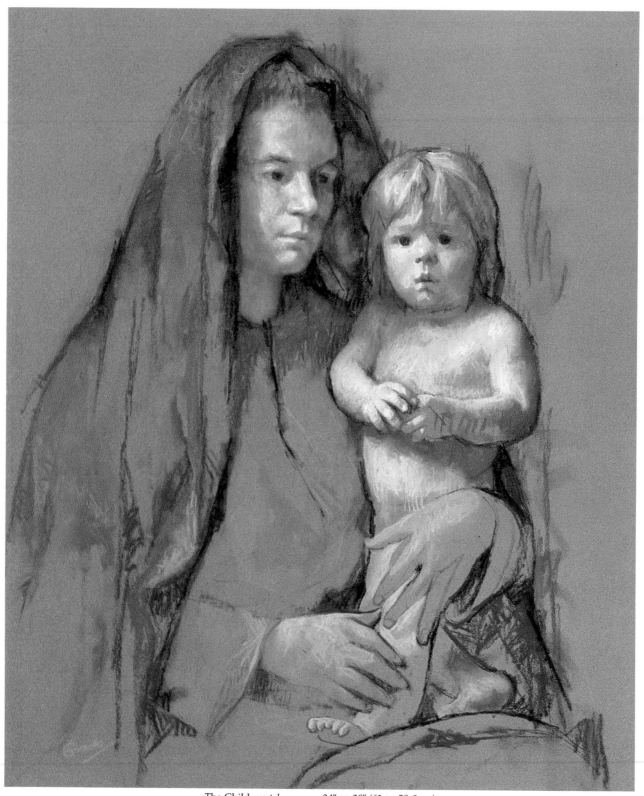

The Child, *pastel on paper, 24″ × 20″ (61 × 50.8 cm)*

Lessons from Reilly

The lessons in this section stem from the notes I took in Frank Reilly's classes. The focus is on drawing and painting the figure—a good starting point for any art student. Once you learn how to deal with the problems in painting the figure, you can easily transfer this knowledge to any other situation.

Reilly's teachings, then, extend far beyond the figure—they introduce you to the underlying craft of drawing and painting. In mastering this craft, you will develop the control you need to expand in other directions.

The important thing to remember as you study these lessons is that the ideas are part of a learning process. Don't be concerned with "your way" or "your interpretation." That will come later. For now, just stay with the correct procedures and repeat anything that seems difficult. As you practice, you will be developing your skills, and it will also help you to understand what you are doing. And if you don't get it right at first, don't become discouraged. I remember reading somewhere that Leonardo da Vinci was an apprentice for almost fifteen years before he felt confident enough to open a studio of his own. "Practice makes perfect"—but only if you know what you are doing.

Drawing is the first step in learning the language of painting. Drawing is itself a language of symbols. There are dots for indicating where important forms should be placed, lines to show boundaries between forms, and patterns that are formed through repetition of similar shapes. When you want to suggest a third dimension, there are additional symbols for indicating form, planes, edges, and perspective.

Drawing teaches you how to understand what you're seeing in nature and express it simply and clearly. It isn't a matter of copying what you see. Instead, you have to be able to conceive it and translate it onto your paper or canvas.

Having a conception when you draw means that you must know what each line is for and where it is going before you begin. You start with the longest lines and gradually work to the smaller ones. This means you must *think* before you put pencil to paper.

PRACTICE EVERYTHING

The lessons in this section present different principles for you to remember in drawing the figure. The best way to understand this information is to try it out as you go along. If you can't work from a nude model, use a clothed figure. Do quick sketches while a friend is reading, or ask someone to pose briefly for you. The important thing is to practice.

As you practice each point, you will absorb different ways of looking at the figure and understanding what you see. Try to master one point at a time. Don't worry about learning everything at once. There are a lot of ideas here, and you may find some principles more helpful than others. But you have to learn all the different rules before you can know which ones you want to eliminate and which to keep.

When you practice, I suggest you use the following supplies:

18" × 24" newsprint pad

No. 2B Wolff carbon pencil sharpened to a point, then sanded down to three flat, pyramidal sides

Kneaded eraser

WOLFF'S CARBON PENCIL 2B

Line

There are three kinds of line:

1. LIGHT vs. DARK lines

*Use light lines
for subtlety.*

*Use dark lines
for emphasis.*

*Variations in light
and dark can suggest
three dimensions.*

2. THIN vs. THICK lines

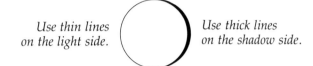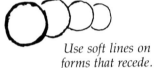

*Use thin lines
on the light side.*

*Use thick lines
on the shadow side.*

3. SOFT vs. HARD lines

*Use hard lines on
forms that project.*

*Soft lines
describe
soft edges.*

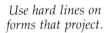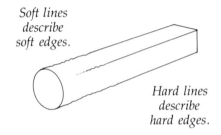

*Use soft lines on
forms that recede.*

*Hard lines
describe
hard edges.*

A line should be put down with SURENESS.
A line should be put down with GRACE.
A line should be put down with ACCURACY.
A line should be FREE and EASY.

ASSIGNMENT

To train your arm and hand, practice drawing these lines every night. Try to get the lines to curve in a free and easy fashion. Let them flow naturally. Make them large and use your entire body to draw them—work from the shoulder, not the wrist.

Relationships Between Lines

The most important principle to keep in mind as you draw is that of relationships. Every line you put down in your drawing must relate to another line that is already there.

Every line must grow out of or connect to something.

But one line should not go into another head-on.

The relationship can be created by several lines, instead of one or two.

And, even though everything you put down must be related, the lines don't have to line up.

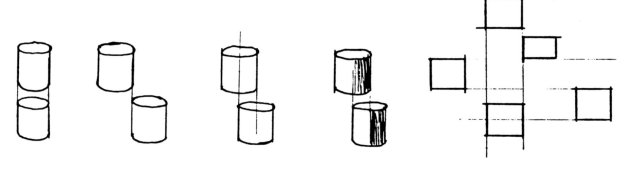

The lines of forms can relate in many different ways.

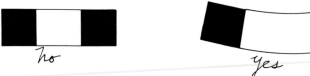

When you draw the human figure:
1. *Relate the closest things first.*
2. *Relate the longest lines too.*
3. *Relate from big forms to smaller ones.*
4. *Always relate with a flowing, curved line.*

REMEMBER: Every line must come from somewhere and go somewhere.

String of Pearls

Before you can draw a form like the human figure, you must determine its basic action—the gesture. This action imposes order on the subject. It holds the individual pieces of the composition together.

To explain this concept, Reilly used the now-famous example of a string of pearls. If you were to draw a necklace, pearl by pearl, the result would be a chaotic and disjointed series of balls. The only way to make sense of the pieces is to draw the *direction* of the string that connects the pearls first. This is the longest line of action: it shows the movement of the parts. Once this is drawn, you can put the individual pearls (the details) on that line.

Apply this principle to everything you draw: First draw the conecting string—the largest action. Then put on the forms.

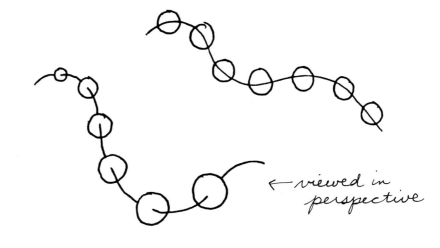

← viewed in perspective

Just as you draw a log before the bumps, put the main action line down before the forms. Then the forms have something to rest on and somewhere to go. They have a direction and movement.

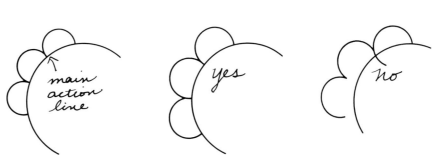

main action line

yes

no

Every line must explain an action in drawing. DON'T use stiff, jerky piecemeal lines. Choose long, graceful lines that connect one form to another.

Lines of action can go into and out of forms.

But make sure that every line that is on a form goes around it.

Action and the Longest Line

Put the longest lines down first.

Put the biggest relationships down first.

Don't draw the outline—instead, look *inside* the forms.

Use as few lines as possible and choose the most expressive ones.

Decide where the main line begins, where it is going, and where it ends *before* you start to draw.

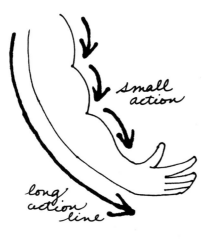

In drawing a form like the arm, first determine the long line of action. The small action should relate to this line.

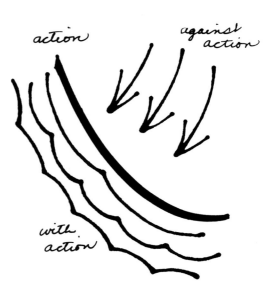

Everything relates to the main action line. It enables you to see what is with the action and what is against it. To bring the flow of the figure, accentuate what goes with the action.

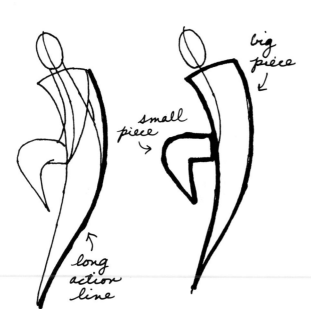

The long action line here gives the flow of the figure. By simplifying the figure's action into the big piece and the small piece, you see the essentials of the movement. To get the stance of the figure right, you must see its action.

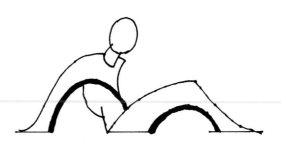

When the figure is resting on the ground or some other support, look for the points of contact. Find the line of action between these points. Again, this will give you the thrust of the figure.

The Six Lines To draw the action of the figure, locate the six important lines of the figure. On the stationary body, the six lines are:

 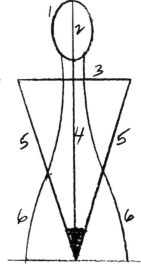

1. *Head* **2.** *Center line to pit of neck* **3.** *Shoulder line*

4. *Center line from pit of neck to crotch* **5.** *Shoulder points to crotch point* **6.** *Jawline beneath ear to width of hips*

The rest of the body follows on these six lines.

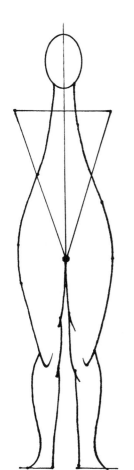 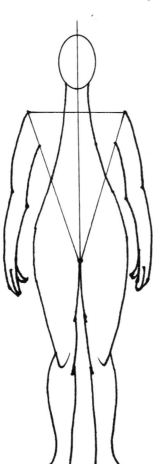 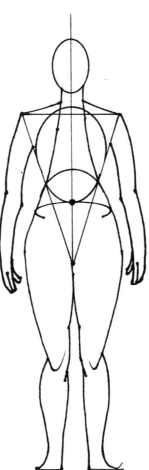 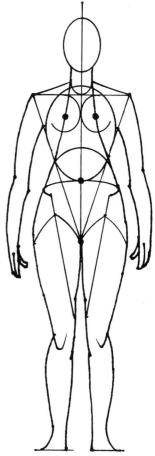

Add the legs in simple lines, starting with inside line.

Draw the lines of the arms.

Add the rib cage and pelvic forms. Also indicate the related iliac crest.

Complete the basic structure by showing the breasts, neck form, and leg forms.

Axis, Boundary, and Station Points

Because the silhouette does not explain the forms well enough, you must work inside the form.

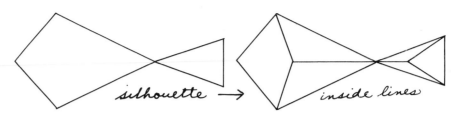

Every form has an *axis*—a direction or thrust—and a *boundary*, or outside shape. The axis of a form describes its action. You can find the axis where the boundary lines cross.

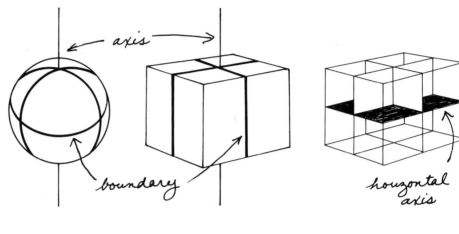

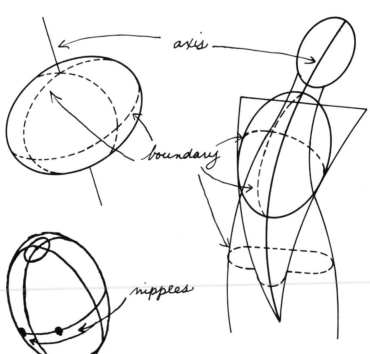

To visualize the boundaries and axis of the rib cage, picture a black thread glued onto a hard-boiled egg. Note the tilt of the axis and the way the nipples follow the curve of the form along the boundary line.

There are three kinds of action on the figure:
1. up and down
2. side to side
3. in and out (perspective and foreshortening)

To emphasize the action:

First draw a line through the pit of the neck and crotch, continuing down the inside of the legs. (A)

Next put in all the lines that relate to this central (long) action line. (B)

Now add the top planes or boundaries of the form to explain the perspective. (C)

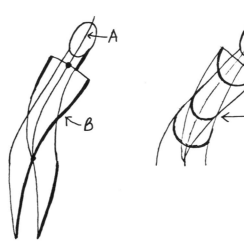

Remember:
- The outside shape is what the action is put into. It contains the action (axis) but does not necessarily show it.
- Always work from big forms to smaller ones. Put in the rib cage, then the breasts, then the nipples.

ALSO LOOK FOR STATION POINTS

The station points are points on the body that show you the direction of the action. They also help you line up the forms.

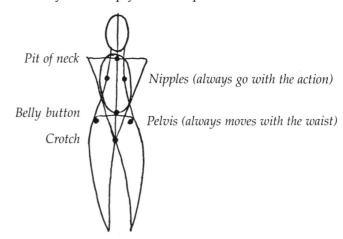

Forms in Action

To capture the action of the figure, remember:
- The center of balance for the whole figure is the center of the head. (A)
- All action points on the figure are related to the pit of the neck. (B)

DETERMINE THE BASIC ACTION

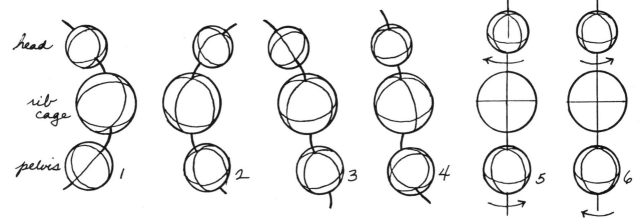

head

rib cage

pelvis

1 2 3 4 5 6

If you think of the body as forms lined up along a long axis line, you'll be able to understand and visualize how the forms tilt and turn as the body moves.

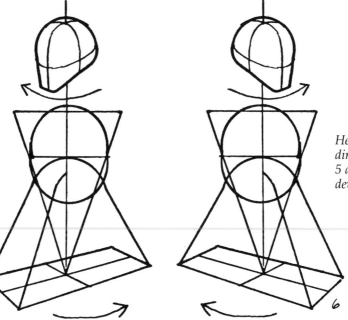

5 6

Here you can see how the directional lines in positions 5 and 6 can guide you in developing the forms.

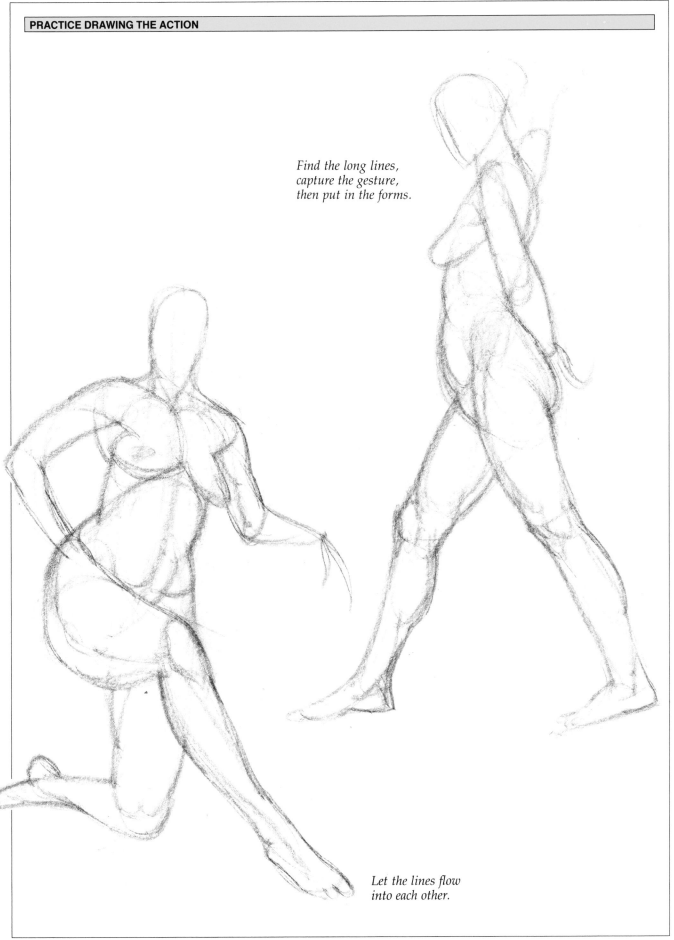

*Find the long lines,
capture the gesture,
then put in the forms.*

*Let the lines flow
into each other.*

From Action Points to Form

There are four points on the figure where the boundaries show action. These action points are helpful guidelines.

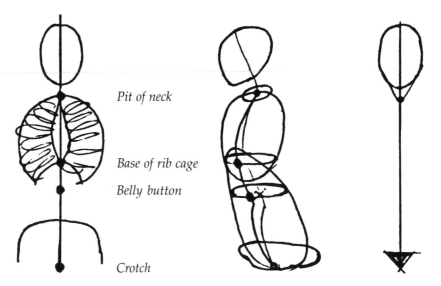

Pit of neck

Base of rib cage

Belly button

Crotch

Remember that the line from the pit of the neck to the crotch indicates the direction of the action.

In locating the boundaries on the model:
• Look for the parts of the rib cage that show on the body's surface.
• Look for the parts of the pelvis that show on the body's surface.

Boundaries and action points relate to the long line of action:

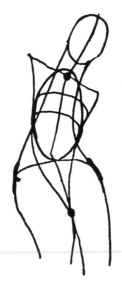

Here the long line of action breaks at the center of the back.

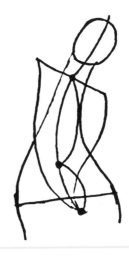

In this case, the long line of action breaks at the belly button.

IMPORTANT: In drawing, action must come before form.

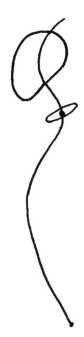

Establish the main lines, as in this profile view.

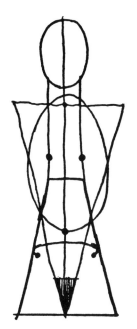

Determine the six lines and the station points, as in this front view.

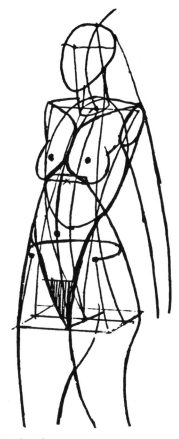

In this three-quarters view, you can see how the forms are developed in relation to the action lines.

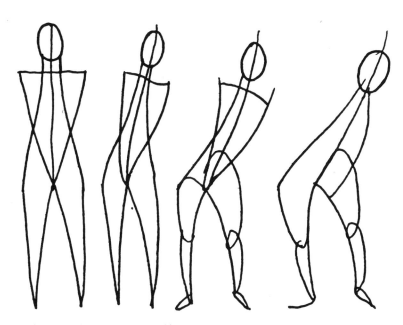

Before you draw, ask yourself:
• Which ACTION do you want to emphasize?
• Which FORM RELATIONSHIPS should you emphasize?

Connections Between Forms

In drawing the figure, always think of relationships. All lines that radiate from one form, for instance, should connect to a line on another form.

A. The rib cage relates to the side of the body, then to the crotch.

B. The rib cage relates to the belly button.

C. The side of the neck relates to the rib cage, then to the pelvis and the side of the leg.

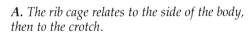

Another relationship is between flat and round shapes. The neck and the waist are important connecting forms. Their lines relate to each other, and their shapes are flat as opposed to the round forms of the pelvis and rib cage.

Notice how the round shapes are connected by flat shapes.

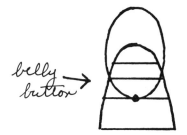

The belly button connects two forms.

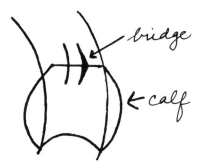

The hamstring muscles form a bridge, connecting the calf and the thigh at the back of the knee.

Pay attention to how and where the forms connect.

And always look for the action. Is there a change of movement at the point where the forms connect?

Forms can bend.

Forms can twist.

Forms can be at right angles to the action.

WORK FROM LARGE TO SMALL

Once you have the large shape, look for the smaller forms within it. Keep the outline simple and draw as much as possible from the inside. Note, for example, the breast and belly within the form of the torso and the developing forms of the thigh and crotch.

CONSIDER THE OUTSIDE ENVELOPE

Each pose can be seen as enclosed within a large shape, or envelope. This envelope can clarify relationships between the outside lines of the forms.

Here the line from the top of the head goes into the outside line of the upper arm (A) and then relates to the outside line of the leg (B). Notice how the envelope reveals the triangular outside shapes. This, too, is a guide to how to make all the outside lines of forms relate to each other.

Remember, however, that all outside lines on the figure should be curved. Keep the sides of the outside triangle curved, not straight.

Inside the Forms

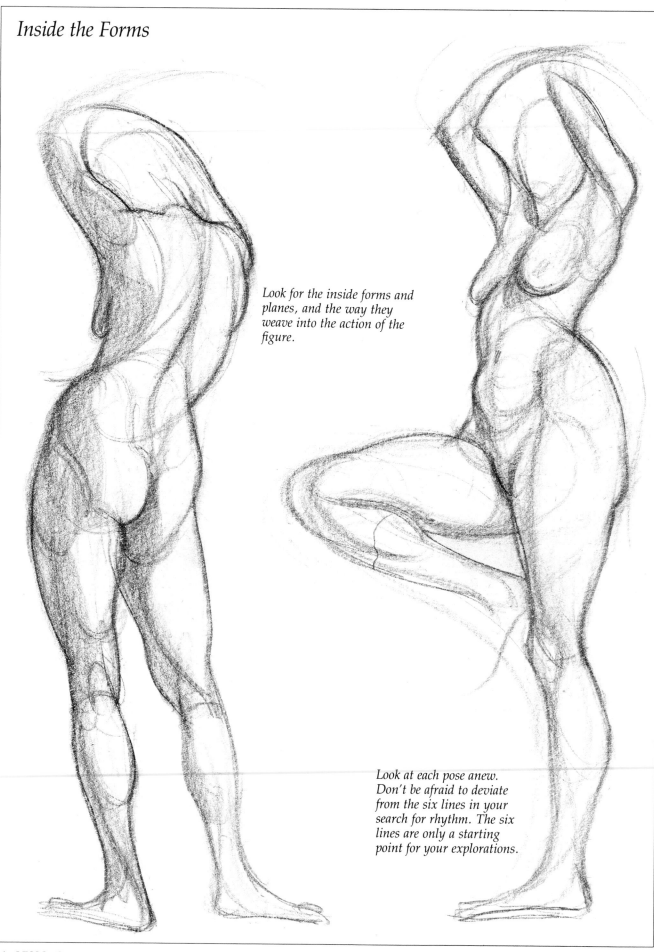

Look for the inside forms and planes, and the way they weave into the action of the figure.

Look at each pose anew. Don't be afraid to deviate from the six lines in your search for rhythm. The six lines are only a starting point for your explorations.

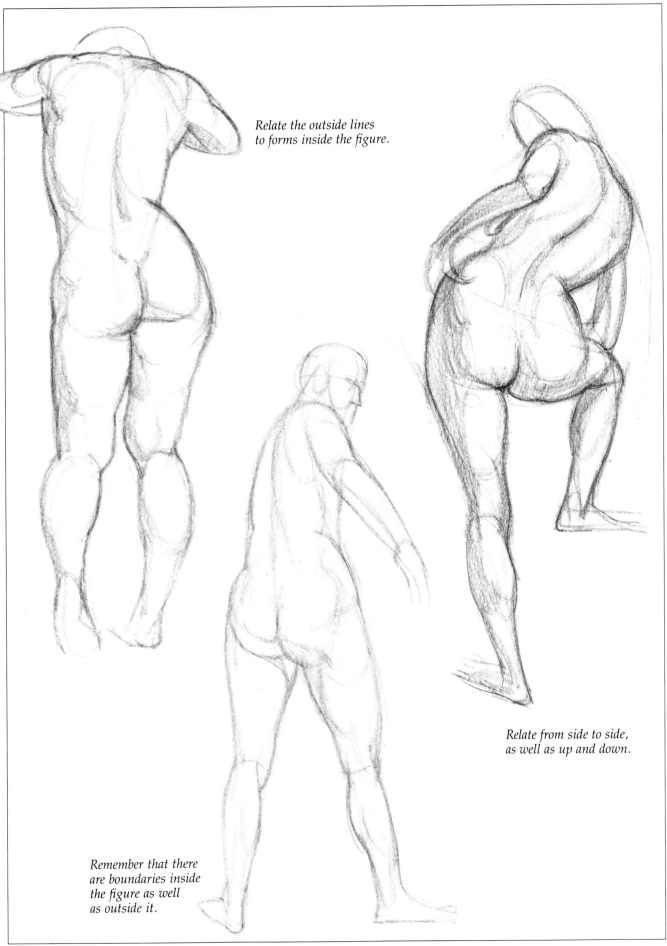

Relate the outside lines
to forms inside the figure.

Relate from side to side,
as well as up and down.

Remember that there
are boundaries inside
the figure as well
as outside it.

Symmetry and Other Relationships

Whenever there are two similar forms on the body, draw them at the same time. When you draw one arm, for instance, also draw the other arm. When you draw one leg, also draw the other leg.

Work with relationships:

- Each limb relates to the opposite side of the body (one arm relates to the other).
- Each limb relates to its opposite limb (the right arm relates to the left leg).
- Each limb relates to itself (the upper arm relates to the lower arm and wrist).

1. *Relate each arm to the opposite leg.*

2. *Relate arms to upper body.*

3. *Relate legs to upper body and head.*

4. *Relate one leg to the opposite arm.*

5. *Relate one leg to the other leg.*

6. *Relate one arm to the other arm.*

Always relate from side to side to establish the natural symmetry of the body. Pay attention to the flow of movement on both sides of the body.

Look at leaves and other natural forms to see how they grow.

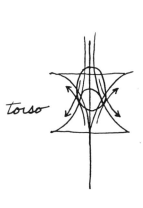 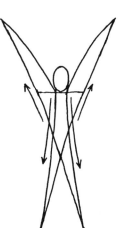 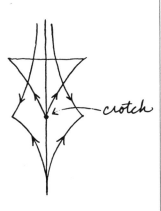

torso

crotch

Now compare the movement in different areas of the figure.

Don't make the curves on a form even. Look for points where the form narrows or thickens, giving variety to the curves.

no *yes*

By nature, the body of the male is lean and narrow. The female is usually broader and bulkier.

male *female*

male

female

Differences between the male and female are especially apparent in forms like the buttocks or breasts.

The Importance of Relationships

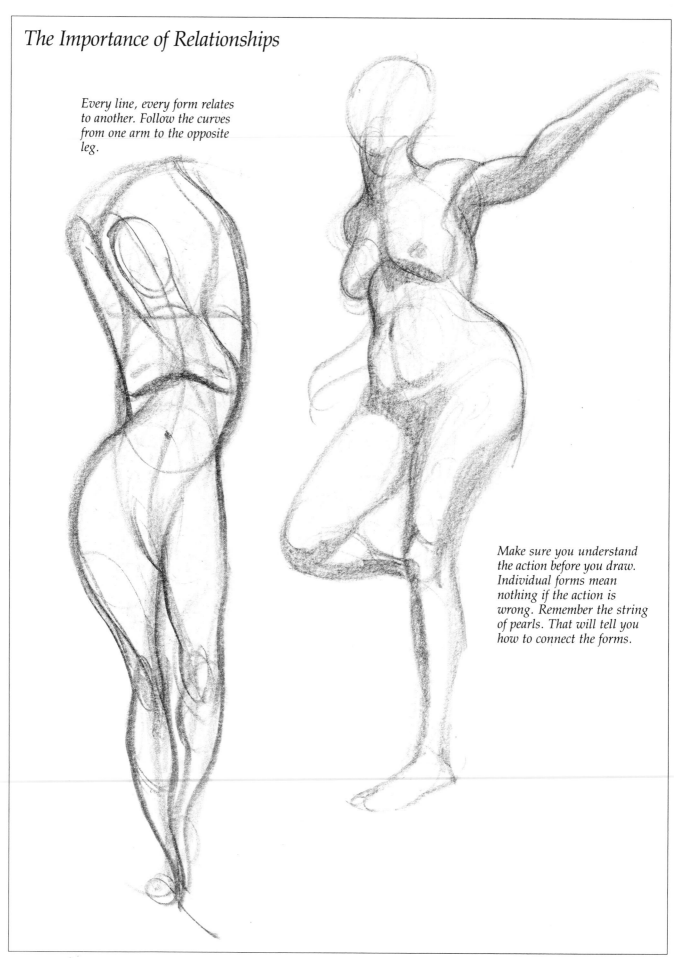

Every line, every form relates to another. Follow the curves from one arm to the opposite leg.

Make sure you understand the action before you draw. Individual forms mean nothing if the action is wrong. Remember the string of pearls. That will tell you how to connect the forms.

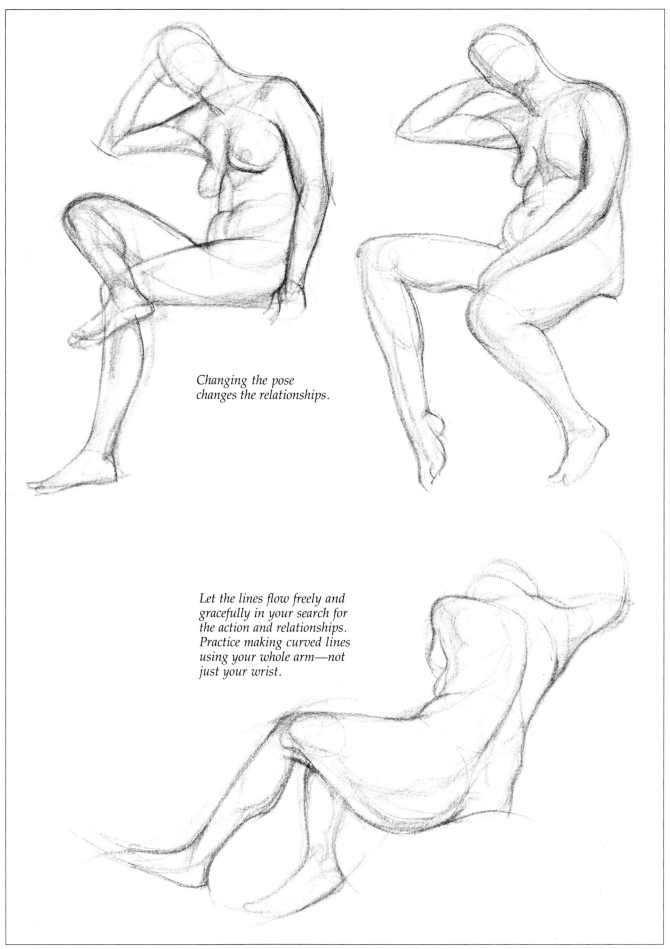

Changing the pose changes the relationships.

Let the lines flow freely and gracefully in your search for the action and relationships. Practice making curved lines using your whole arm—not just your wrist.

Connectors and Action

Most action happens at the connectors—points where the action shifts direction, such as the pit of the neck. A connector (like the pit of the neck or the wrist) is usually smaller than the forms it connects (the head to the rib cage, the arm to the hand). Connectors allow you to bend—twist—tilt.

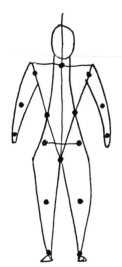

These are the main connectors.

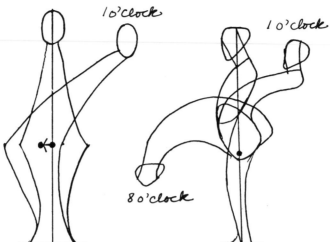

10 o'clock

8 o'clock

10 o'clock

As the head moves to the 1 o'clock position, the connector at the crotch moves to the left.

Note that the head can be at the 1 o'clock or 8 o'clock position without changing the position of the connector at the crotch.

The shoulders and the hips can be turned in opposite directions without any change in the connector at the crotch.

EXPLORE THE VARIETY OF MOVEMENT

Each part of the body can move in many different ways.

The head can bend forward and tilt backward.

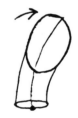

The head can also bend right or left and twist right or left.

Observe how the movement of one part affects another.

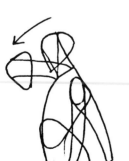
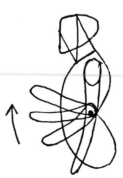
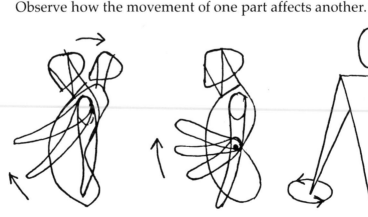
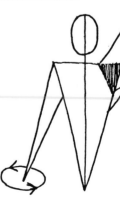

The extended muscle under the arm makes the torso look wider when the arm is raised.

As the arm moves back, the head tilts forward.

As the arm moves forward, the head tilts back.

After the lower arm is raised more than 100°, the upper arm moves.

You can rotate the arm quite a bit before the elbow starts to move.

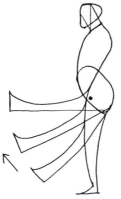

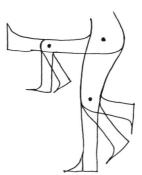

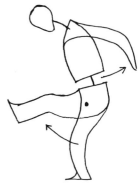

The leg can be raised 90° before the connector at the crotch must move.

At the same time the knee can bend in many ways.

For every action, however, there is a counteraction. When the leg moves forward, the arm moves back.

RELATE THE LINES OF MOVEMENT

When the head bends forward and the arm goes back, look for the direction of the lines.

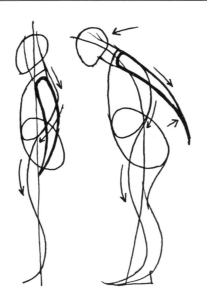

Every curved line must relate to the whole figure.

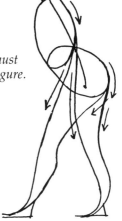

Different postures create different relationships between the main lines and the forms. REMEMBER: Every line of the figure must relate to other lines of the figure.

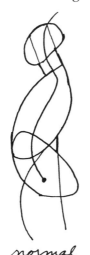

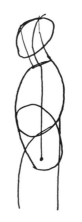

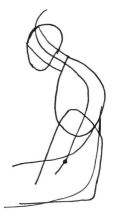

normal　　*looking up*　　*slumped*　*bent forward*

Action and Balance

To determine how the figure is balanced, look for the *points of support*. Make sure they're lined up—or the figure will fall over.

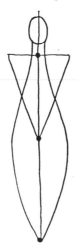 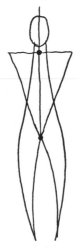 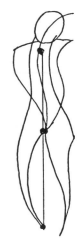

Figure balanced over points of support.

Figure balanced between points of support.

Points of support in action.

Check the *pivot points* to see where the forms are moving from:

The ilium, or pelvic bone protrusion, is the pivot point for the legs.

The crotch is the pivot point for the torso.

Also look for the horizontal and vertical alignments of the figure. This is called *pointing off*.

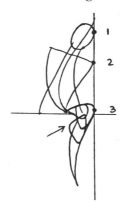

Here the head, shoulder, and knee are pointed off. You can also see how the forms of the calf and kneecap align with the action of the leg.

CHECK FOR COUNTERPOINT ON THE FIGURE

Counterpoint on the figure works in much the same way as a seesaw—if one part of the figure is off-balance, it is counteracted by an equal movement on the opposite side.

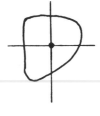

When the forms of the body are at rest, they show a kind of natural counterpoint. With the head, the axis drawn from the pit of the neck to the top balances the front and back. You can also see how the cylinder of the neck form balances the thrust of the head.

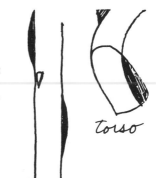

A similar seesaw balance occurs with other forms. On the leg, the curve of the thigh is balanced by the curve of the calf. Similarly, on the torso the breasts balance the buttocks.

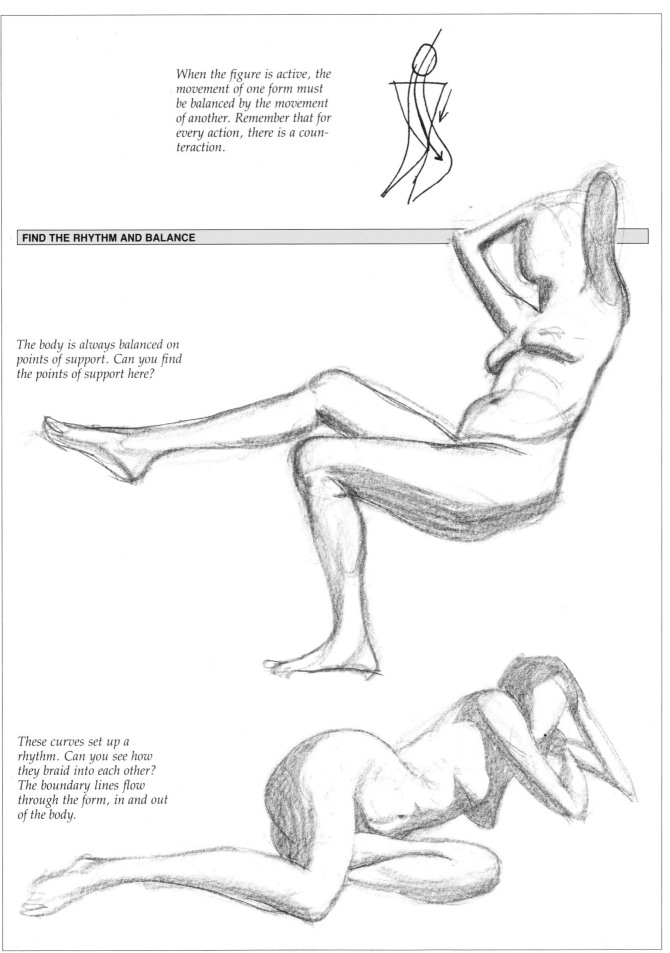

When the figure is active, the movement of one form must be balanced by the movement of another. Remember that for every action, there is a counteraction.

FIND THE RHYTHM AND BALANCE

The body is always balanced on points of support. Can you find the points of support here?

These curves set up a rhythm. Can you see how they braid into each other? The boundary lines flow through the form, in and out of the body.

Weight and Strain In drawing the action, you must consider the effect of strain. The large forms of the body will look different, depending on whether they are relaxed, rigid, or strained.

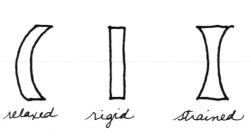

relaxed rigid strained

Observe the difference when one leg is strained and the other is relaxed.

The muscles of the body also take on different shapes, depending on whether they are relaxed, rigid, or strained.

Relaxed muscles bulge at the bottom. *Rigid muscles bulge in the middle.* *Strained muscles bulge at the top.*

Remember that the bulge in the muscle always goes with the action. If the action of the leg is pushing up, off the ground, the muscle will be strained and bulge at the top. When the leg is relaxed, with gravity pulling down, the bulge is toward the bottom.

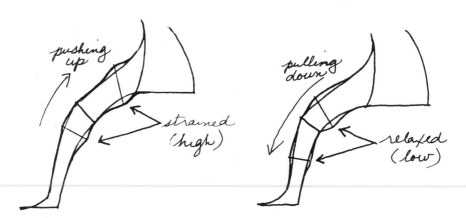

ASSIGNMENT

To understand the difference between relaxed and strained muscles, draw the figure in two different positions:
1. Sitting in a chair (relaxed muscles).
2. Pushing against a wall (strained muscles).

When a form is under pressure, receiving the weight of the figure, it will take on the shape of the surface that supports it.

In drawing a standing fig-ure, let the foot take on the shape of the floor.

In drawing a seated figure, let the buttocks take on the shape of the support.

This model looks seated—even without a chair. Can you see why?

Planes and Forms

The forms of the body are round. In contrast, planes are flat, two-dimensional areas of a form. They show the character of the form and help to describe its shape—telling you about its front, top, sides, and bottom.

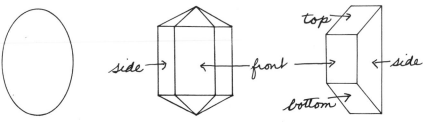

The basic form of the head is egg-shaped.

To find the major planes, imagine that you are slicing off the round edges to leave a flat surface.

A round form must have a top, front, side, and bottom plane.

Planes connect the corners of a form.

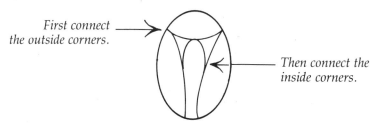

First connect the outside corners.

Then connect the inside corners.

Planes must stay on the form. But planes can relate to each other and to the form in different ways.

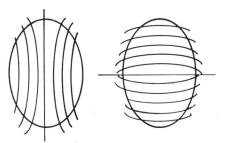

There are vertical and horizontal planes.

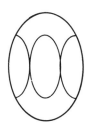

There are planes that touch.

There are planes on planes (for instance, the nose on the head).

There are overlapping planes.

A plane can connect two forms.

A form on a form can be connected by a plane.

You can repeat (parallel) a plane that's already there.

In deciding which planes to emphasize, look for the ones that will clarify the form and the action.

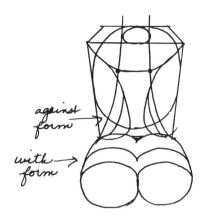

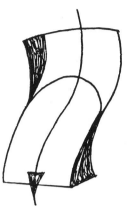

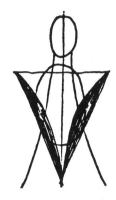

In general, where the form is bulky, show how the planes go with the form. Where the form is leaner, show how the plane goes in the opposite direction, against the overall form.

In drawing a form like the torso, show how the planes go with the action.

Look for the places where one plane meets another. There is a hard edge here, like a corner, which catches the light.

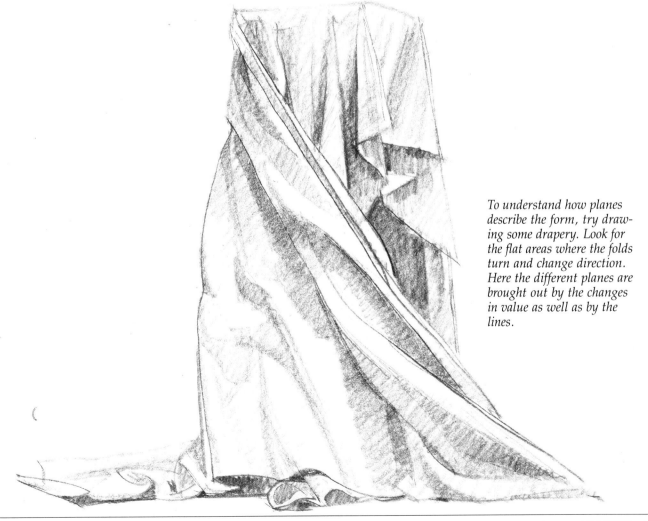

To understand how planes describe the form, try drawing some drapery. Look for the flat areas where the folds turn and change direction. Here the different planes are brought out by the changes in value as well as by the lines.

Foreshortening

Foreshortening is affected by five factors:
1. Location of pivot points.
2. Length of forms (e.g., thigh to kneecap to foot).
3. Size of the extremes (e.g., one hand larger than another).
4. Overlapping forms (where this is not usual).
5. Location of centers of forms (e.g., nipples higher or lower than usual on rib cage).

Always compare foreshortened forms to normal ones. Since straight lines are easy to put in perspective, try boxing in the curved lines to see how they should be foreshortened. The greater the foreshortening is, the more curved the line will become.

To decide whether a form is foreshortened, measure the distances between the normal midpoint and the extremes. If they are unequal, then the form is foreshortened.

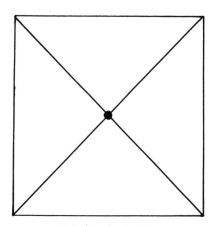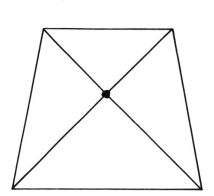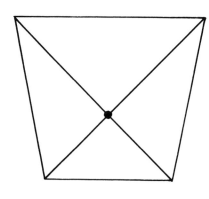

No foreshortening.

When the top of the form goes back, the center moves up.

When the bottom of the form goes back, the center moves down.

When you foreshorten a limb, look for the pivot point. The pivot point is the center of action, and what happens to the form will depend on whether the pivot point is at the center, top, or bottom.

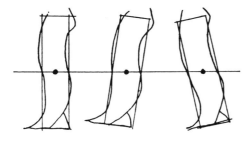

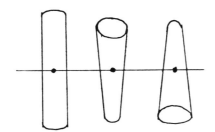

The pivot point can be at the CENTER.

*When the pivot point
is at the center:*
* *The center stays the same.*
* *The size of the ends changes.*
* *The length changes.*

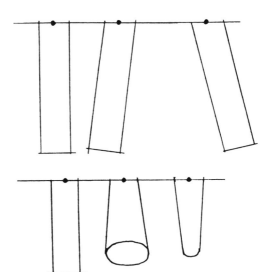

The pivot point can be at the TOP.

*When the pivot point
is at the top:*
* *The top stays the same.*
* *The bottom size changes.*
* *The length changes.*

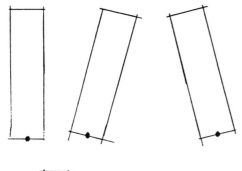

The pivot point can be at the BOTTOM.

*When the pivot point
is at the bottom:*
* *The bottom stays the same.*
* *The top size changes.*
* *The length changes.*

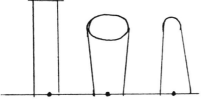

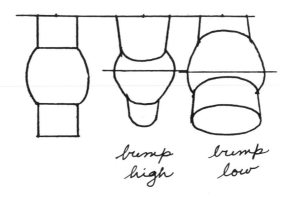

*bump
high* *bump
low*

With forms with a center "bump" like the kneecap, make sure:
• *When the form goes back, the bump moves up.*
• *When the form comes forward, the bump moves down.*

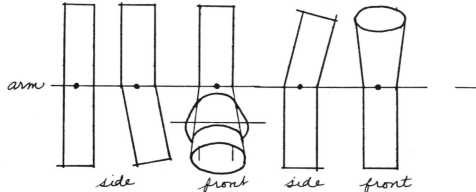

arm

side *front* *side* *front*

no *yes*

*Always make one
part of the arm bend
more than the other
part of the arm.*

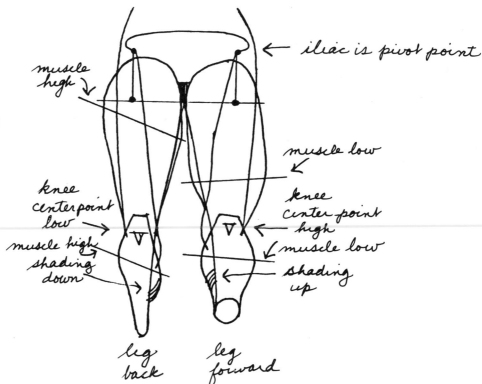

*Here you can see the
differences when one leg
is back and the other
is forward.*

← *iliac is pivot point*

*muscle
high*

muscle low

*knee
center point
low* →

*knee
center point
high* ←

*muscle high
shading
down*

*muscle low
shading
up*

*leg
back* *leg
forward*

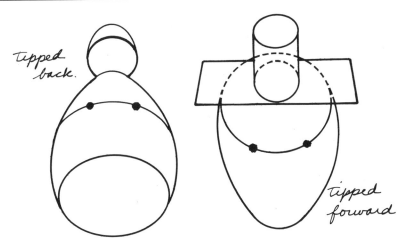

Tipped back.

Tipped forward

When the head and chest are foreshortened, the forms that you can see change. Notice also how the nipples move up or down.

Always draw the extremes—the nearest and furthest ends—first. Then draw the connecting lines between them.

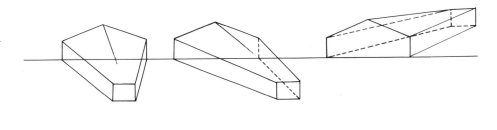

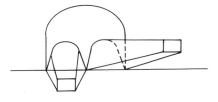

Draw the known quantities first. Then connect the lines between them.

Align the muscle bulges so that they fall into the correct perspective.

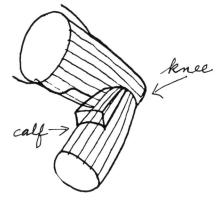

knee

calf →

Shadows

Shadows show the *form* and *action* of the figure.
Let the shadows follow the boundaries.

*Here the shadow
shape follows
the form of the head.*

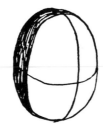

Make the main shadows define the action.

Shadows are at a right angle to the source of light.

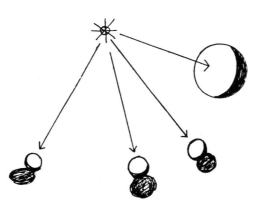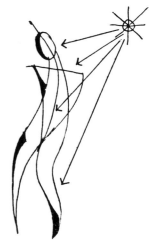

The dividing line between light and shade describes the distance
between an object and a light source like the sun or a lamp. The light
becomes more diffuse and softer as the object moves away from it.

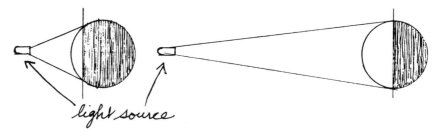

light source

The division between light and shade is called the *halftone*. Its direction
should show the shape of the form. The halftone is hard-edged when the
change of direction is drastic (for instance, at a corner). It has a softer
edge when the change is more gradual, as on a round form.

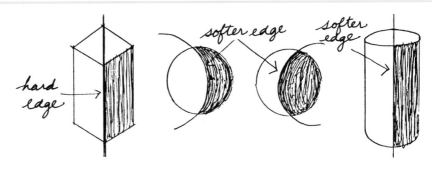

*hard
edge*

softer edge

*softer
edge*

In drawing the figure, always relate the shadow to the action—not the outside shape of the figure.

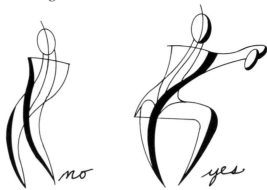

Start by indicating how the shadows go with the action. Then, once the action is established, model the shadow on each form separately.

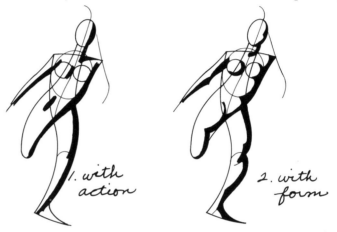

When you put in the shadow, first indicate its shape as simply as possible. Next add the variations on the outside form. Then put in the small variations on the inside that describe the shapes of the small, inside forms and muscles.

Pay attention to how the shadows describe the form.

Any shadow that crosses a form, for instance, makes a twist.

Sometimes shadows will skip a form to make the next connection.

REMEMBER: Don't make the outside edges of the shadows too bumpy or they will interfere with the flow of the action. Notice where the halftones are to keep the transitions smooth.

Shadows

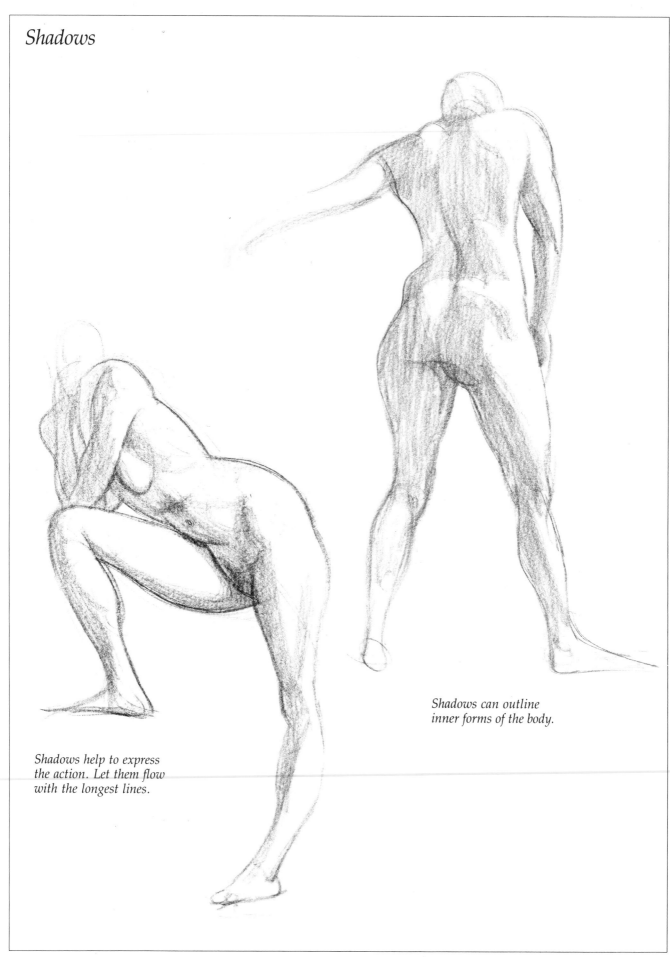

Shadows help to express
the action. Let them flow
with the longest lines.

Shadows can outline
inner forms of the body.

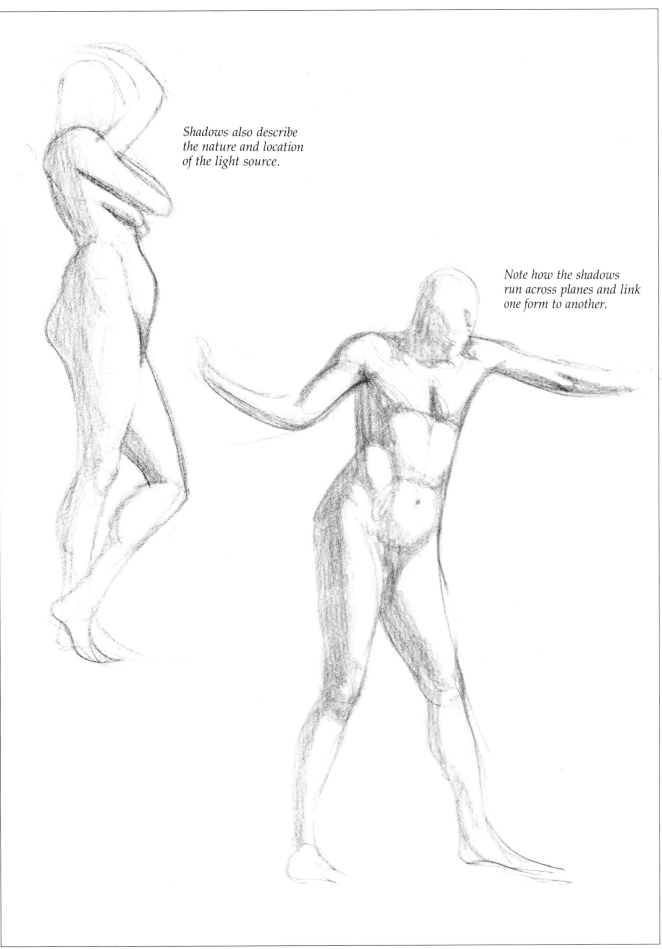

Shadows also describe the nature and location of the light source.

Note how the shadows run across planes and link one form to another.

Cast Shadows

Like shadows, cast shadows have no direct light on them. Reflected light, however, can lighten them, or surrounding walls can darken them.

Cast shadows always go in the direction of the light source, and they show the shape of the object casting the shadow.

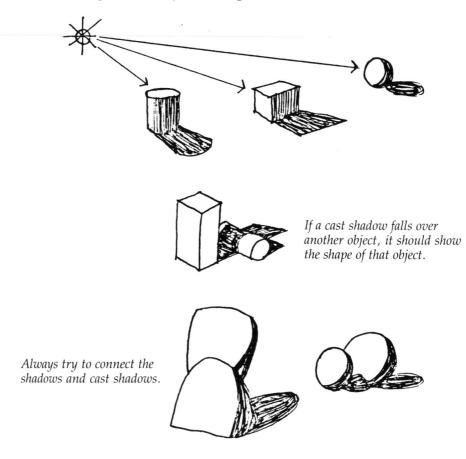

If a cast shadow falls over another object, it should show the shape of that object.

Always try to connect the shadows and cast shadows.

Whenever a cast shadow does not follow the action or define the form of the object casting it, leave it out. For example, if a shadow cast by the arm on the torso does not follow the action or define the form of the arm or torso, leave it out.

The length of a cast shadow is determined by the angle between the model and the light source.

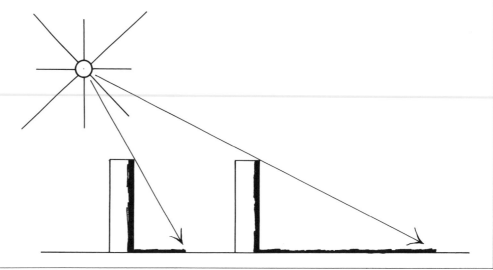

Pay attention to the edges of cast shadows.

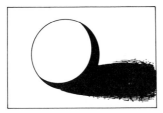

A cast shadow has hard
edges near the object, but it
gets softer as it moves away
from the object casting it.

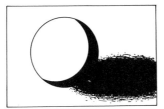

If all the edges on a cast
shadow are soft, then the
object is not touching the
surface on which the
shadow is cast.

Use cast shadows
to bring out the
form and situate
the object in space.

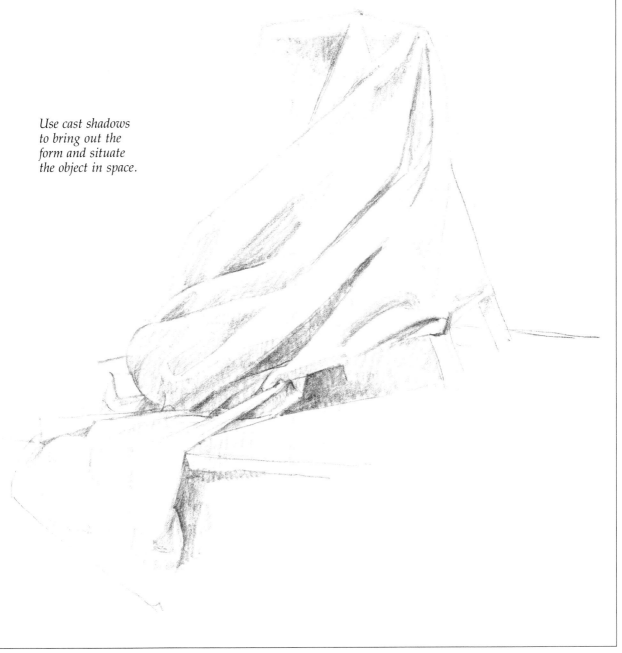

Planes and Light

The position of light dictates which planes are most important. The planes brought out by the light and shadows help to describe the action.

As the light moves, the masses that stand out on the form will change.

 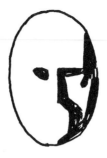 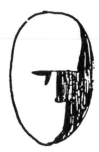

Head under moving light

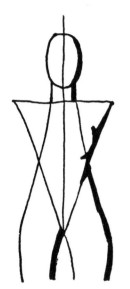

Standing figure under moving light

ASSIGNMENT

Set up a light source that you can move. Do five quick sketches of the figure. First shine the light from the front, directly on the figure. Then move it progressively 20, 40, 60, and 80 degrees to one side. How does the lighting affect your drawing?

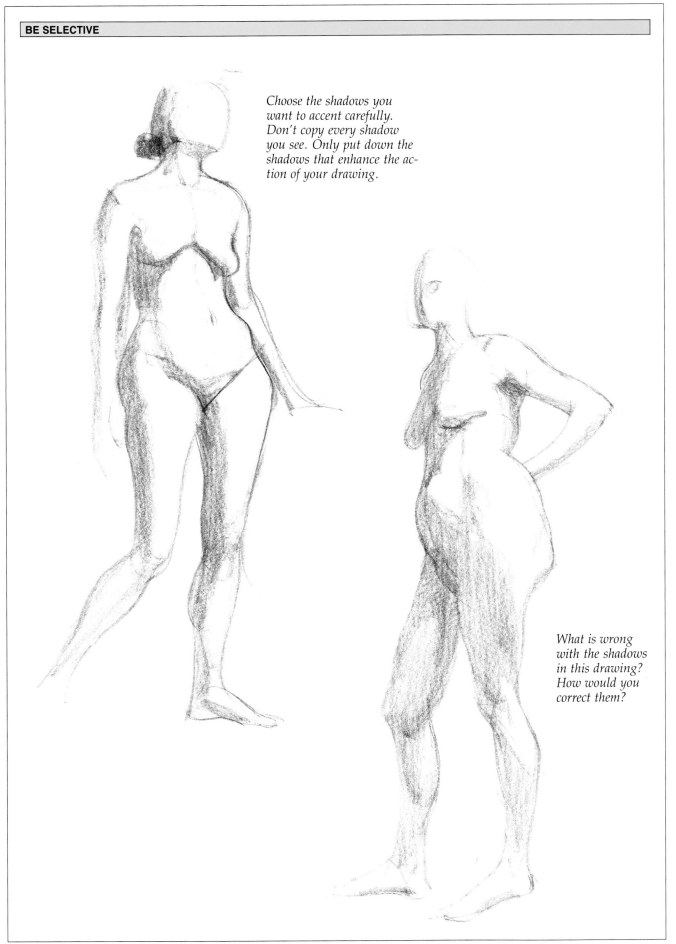

Choose the shadows you want to accent carefully. Don't copy every shadow you see. Only put down the shadows that enhance the action of your drawing.

What is wrong with the shadows in this drawing? How would you correct them?

Structure
of the Head

In drawing a head, you need to understand all of its forms and planes. Always work from the large forms and planes to the smaller ones. Use the diagrams on this spread and the next to learn how the large and small forms and planes relate. To do this exercise, you will need six sheets of tracing paper and three colored pencils (red, green, and blue).

LOCATE THE FORMS

1. Take a sheet of tracing paper and copy this diagram in red pencil. Be sure to draw the two rectangles, as this will enable you to line up all the steps at the end. In this first step, you place the features in the correct average position on the head. The width of the nose equals the width of one eye, and the ends of the mouth line up with the center of each eye. In the profile view, the front of the neck goes from the bottom axis of the head to the brow over the eyes, while the back of the neck goes to the axis at the top center of the head.

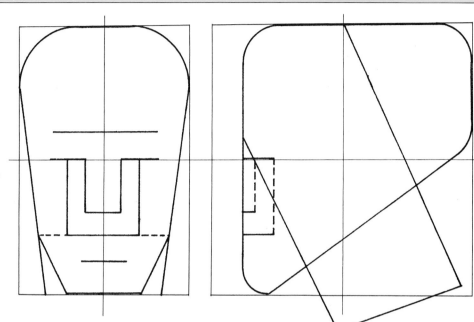

2. Now, on another sheet of tracing paper, copy this diagram in green. The muzzle is the feature to concentrate on in this step. In the profile view you can see the large form for the back of the skull and the top of the jawline.

3. *With blue pencil, trace this diagram on a new sheet. Here you can see the large form of the forehead interlocking with the eye sockets and producing the form for the brow. The cheeks connect with the eye and nose forms to give you the triangular forms below the eyes.*

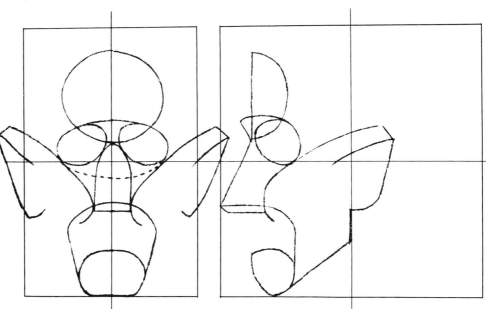

4. *When you place all three sheets of paper on top of each other, you can easily see how all the forms relate.*

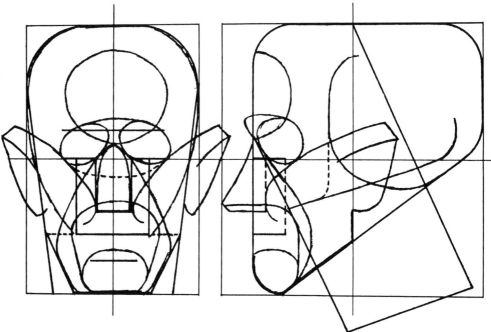

Here are some helpful average proportions to remember:

1. The normal head is 6 inches wide, 9 inches high, and somewhat egg-shaped.

2. The lower lid of the eye is halfway between the top and bottom of the head.

3. The brow is one-fifth the distance from the lower eyelid to the top of the head.

4. The nose is halfway between the brow and the chin, and about one eye wide.

5. The mouth is one-third the distance from the nose to the bottom of the head. The outside ends of the mouth line up with the centers of the eyes.

6. The top of the chin is two-thirds the distance from the nose to the bottom of the head. From the top of the chin to the bottom of the head is the same as from the hairline to the top of the head.

1. *Begin by tracing this diagram in red pencil. When you are drawing a head, look for these large planes first. Once you find these major planes, the other planes are easier to understand.*

2. *As before, use green pencil to trace this second diagram. These smaller planes are a further breakdown of the large planes established in step 1.*

3. Now, with your blue pencil, trace this diagram. These small, complex planes are important in finishing your drawing (or painting) of the head. Getting them right is essential to producing a lifelike portrait.

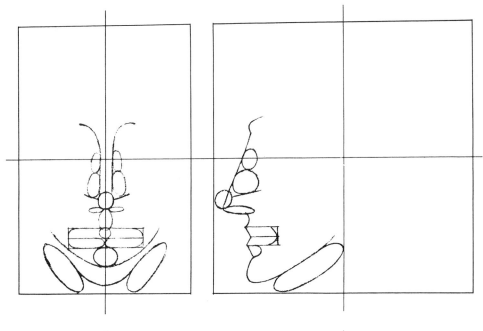

4. When you put your three sheets of tracing paper together, you can clearly see the progression from the large, simple planes to the small, complex planes.

Once you understand these diagrams, practice drawing the forms and planes of the head on your own. Using photographs can be helpful here.

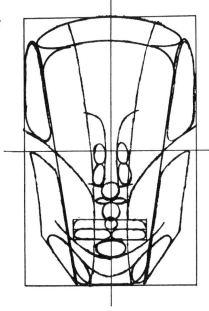
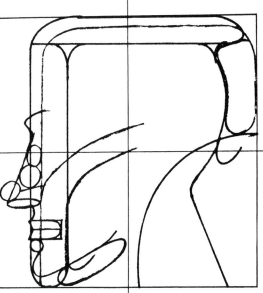

GUIDELINES TO REMEMBER

In drawing the head, once you have established the outside shape, you follow this basic order:

1. Draw the skull and cheekbones.

2. Position the muzzle (the area beneath the cheekbones, including the jawline).

3. Establish the forehead and the hairline.

4. Put in the eyebrows and eyes.

5. Indicate the nose, mouth, and chin.

6. Position the ears.

7. Correct your drawing.

8. Add the minor forms.

Features

To capture a likeness, exaggerate the forms and planes of the head at first. For example, make large eyes even larger or a small nose even smaller. By starting with a caricature, you will discover what to emphasize in your portrait.

The primary features are the eyes and the mouth.
• The eyes are the focal point of the head and give the face some expression.
• The mouth gives the face the most expression.
The nose and the ears are secondary features and should be only suggested at first.

Start with the extreme ends of each feature and then draw the connecting lines to make them full features.

EYES

Start with the brow form. Then add the eye sockets. Then put in the eyeballs.

The iris is half the width of the eye. And the pupil is half the width of the iris (unless there is very little light—then the pupil becomes larger).

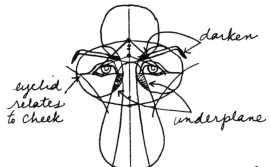

MOUTH

The width of the mouth goes from the center of one eye to the center of the other. The mouth fits into a rectangle.

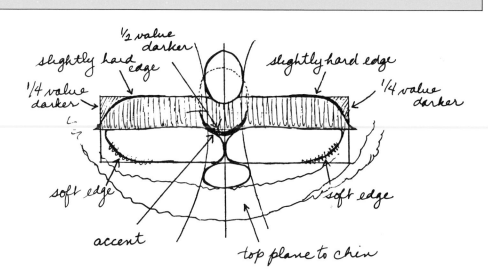

NOSE

Don't make the top edge of the nostril and the top edge of the nose's underplane parallel.

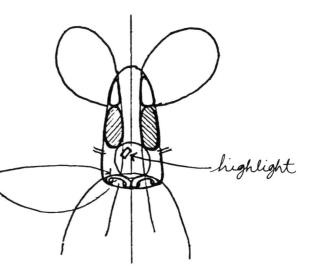

don't make parallel

highlight

EARS

There are no parallel lines in the ear. Look for angles.

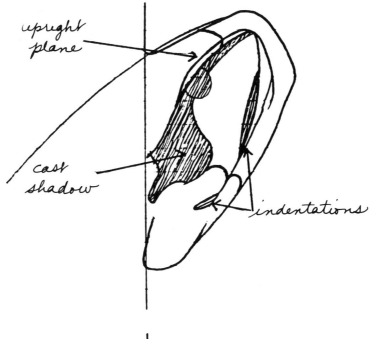

upright plane

cast shadow

indentations

The ear starts behind the central axis of the head. It goes from the top of the brow to the bottom of the nose.

Hair

In modeling the hair, look for its relation to the forms and planes of the head.

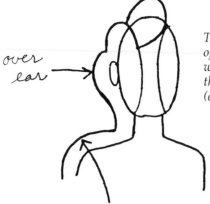

over ear

over shoulder

The outside shape of a woman's hair will be affected by the form underneath (e.g., ears, neck).

When the forehead is short, there is a small area of hair.

When the forehead is long, there is a large area of hair.

When men lose their hair, they lose it on the form of the head.

Basic Growth Lines

Understanding the basic growth lines can help you draw the head.

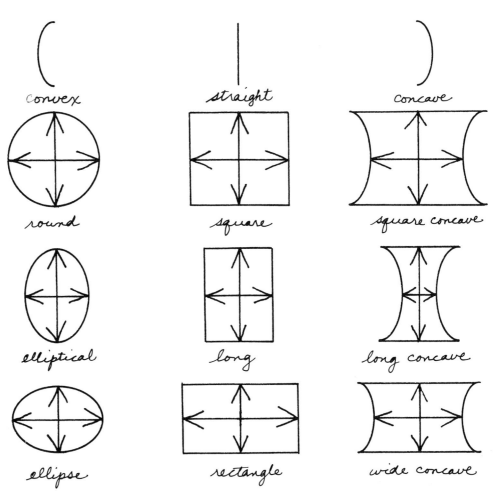

To see how these lines relate to the shape of the head, it helps to divide the head into cross-sections. You can take a cross-section at the widest point, at the center of the form, or wherever you want the center of interest to be.

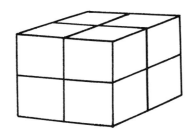

The simplest way to determine the shape of the head is to see how it fits into a cube with the cross-sections shown here.

Dividing the head into thirds also tells you about the outside shape of the head. The size of the features is related to these parts of the head.

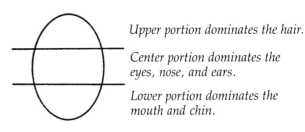

Upper portion dominates the hair.

Center portion dominates the eyes, nose, and ears.

Lower portion dominates the mouth and chin.

Character and Basic Shapes

To capture character, pay attention to:

1. The size and shape of the features on the model (e.g., large nose or ears).

2. The interrelationships of forms (e.g., a small or large head in relation to the body).

3. Differences in the proportions of the forms and planes (e.g., the differences between a fat and a skinny person).

BASIC LINES AND SHAPES OF THE HEAD

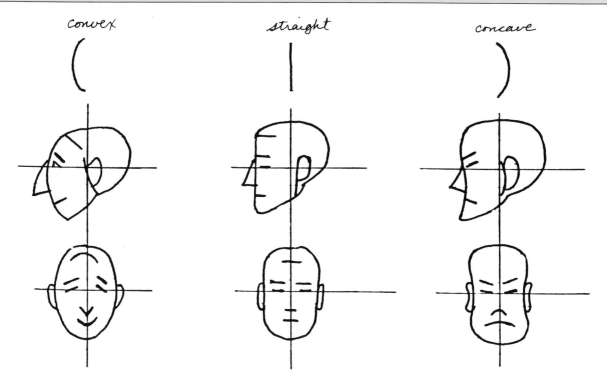

convex straight concave

Note that the size of the basic shape may vary.

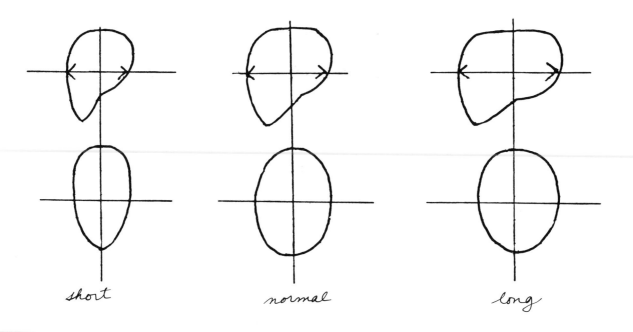

short normal long

There are many other variations of the three basic shapes.

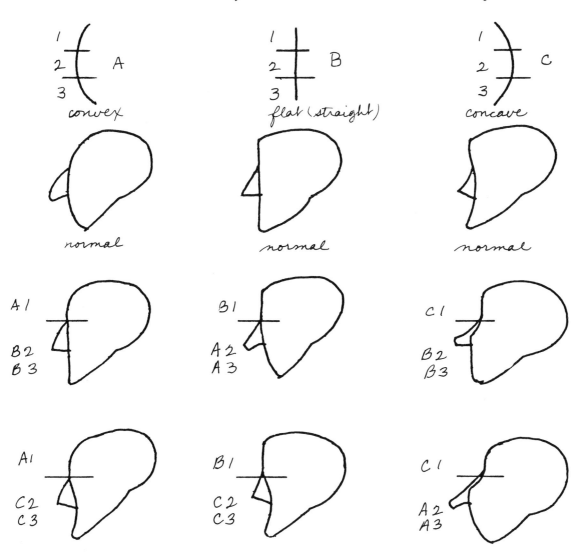

The same basic lines can also break at different points.

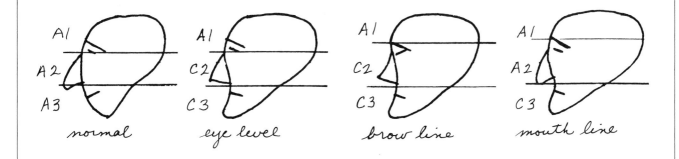

Brows

normal (A)
brows slant up
in front

brows close or
touching — straight

brows close or touching
slant down in front

Forehead

normal (A)

slants back

slants forward

Eyes

normal (A)
eyes slant up

eyes straight

eyes slant down

Nose

normal (A)

slants up

straight

Mouth

*The mouth can
also slant down
or be straight*

normal (A)

close-set eyes

wide-set eyes

Lips

normal

big lower lip

big upper lip

Chin

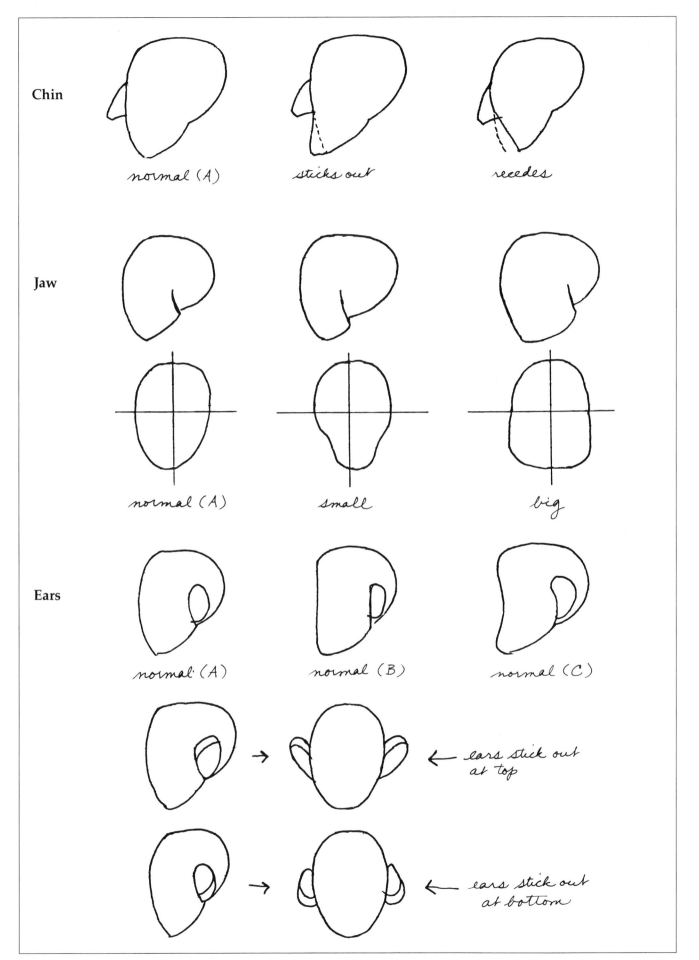

normal (A) sticks out recedes

Jaw

normal (A) small big

Ears

normal (A) normal (B) normal (C)

→ ← ears stick out at top

→ ← ears stick out at bottom

To learn to paint, you have to understand color. Specifically, you must understand hue, value, and chroma (intensity). The assignments in this section are an important first step in this learning process. Do each one carefully and repeat it until you get it right. The understanding you gain will be invaluable, whether or not you use Reilly's method when you paint.

Hue

Hue is the name commonly used for a color—"red," "blue," "yellow," and so on. Reilly used the Munsell system to describe color because of its scientific accuracy. In this system there are five basic hues: yellow (Y), red (R), purple (P), blue (B), and green (G). A color like orange is designated YR. If it is a yellow-orange, it is YYR; a red-orange is YRR.

HOME LEVEL

Every hue has a *home level*, which is its value and chroma as it comes out of the tube. This is the value level at which the hue is at its maximum strength. The chart below shows the home levels for the main hues. You'll want to refer back to it as you read about value and chroma.

HUE	TUBED PAINT COLOR	VALUE	MAXIMUM CHROMA
Y	Cadmium Yellow Light	9	12
YR	Cadmium Orange	7	12
R	Cadmium Red Light	5	14
RP	Alizarin Crimson	1	12
P	Cobalt Violet	2	12
PB	Ultramarine Blue	1	12
B	Cerulean Blue	4	10
BG	Viridian	1	8
G	Cadmium Green	5	10
GY	Yellow Green	7	12

REILLY/MUNSELL COLOR WHEEL

On the Reilly/Munsell color wheel, the five principal hues—yellow, green, blue, purple, and red—are connected by lines to a neutral center. Halfway between these hues are the five intermediate hues: yellow-green, blue-green, purple-blue, red-purple, and yellow-red.

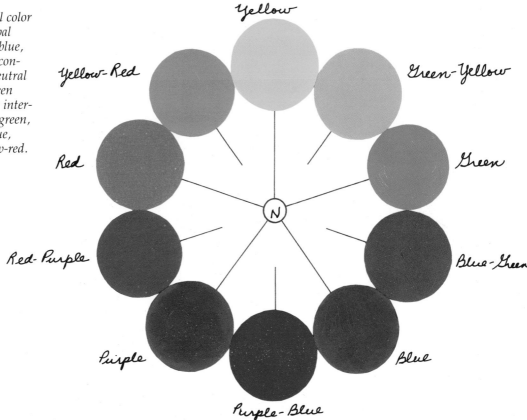

SPECTRUM COLOR WHEEL

Even though the Reilly/Munsell color wheel is more scientific, you may prefer to use the spectrum color wheel because you are more familiar with it. The hues on both wheels are the same. Although orange on the spectrum color wheel is called yellow-red on the Reilly/Munsell color wheel. The important difference is in the positions of the hues, which means that the complementary color combinations differ for each wheel.

On the spectrum color wheel, the primary colors—red, yellow, and blue—are indicated by a gray triangle, while the secondary colors—orange, green, and purple—are indicated by the lines of another, inverted triangle. The tertiary colors are yellow-orange, red-orange, red-purple, blue-purple, blue-green, and yellow-green.

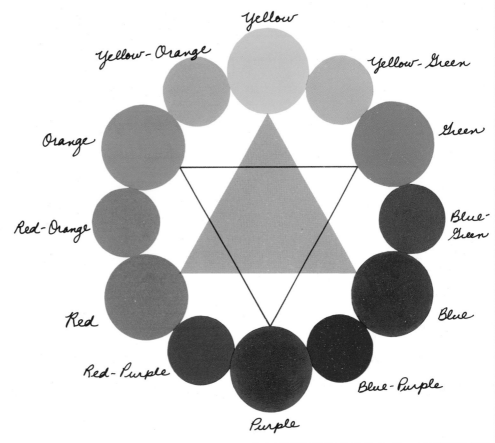

Value

Value is the lightness or darkness of any hue.

If we consider white as 100% light and black as 0% light, we can, for practical purposes, divide the values of each hue into a scale of nine steps between white and black: 90%, 80%, 70%, 60%, 50%, 40%, 30%, 20%, and 10% light.

A nine-value neutral gray scale enables you to measure different hues for specific values. Cadmium red light, for instance, has a value of 5 when it comes out of the tube. If value 7 is needed, you add white to the cadmium red light and measure it against value 7 on the neutral gray value scale.

If you are painting a still life and want to know the value of the light area in the background, lay the scale on the actual background and match the background to one of the values on the neutral gray scale. Then mix a hue to this value on the neutral gray scale. By constantly checking everything with the neutral gray scale, you will train your eyes to see things in terms of value. Try squinting your eyes while checking a strong-chroma hue, as this will allow you to compare the value more easily.

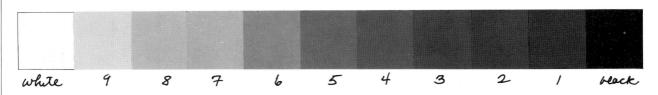

white 9 8 7 6 5 4 3 2 1 black

ASSIGNMENT

Make a nine-value neutral gray scale. Although you can paint this gray scale on any support, I recommend illustration board because it is easy to work with. First give it a coat of shellac or acrylic gesso to seal it from the oil paint. Prepare enough boards to complete several charts, as you will want to make hue and chroma charts, too. Moreover, you may have to repeat the gray scale if you make mistakes. In fact, very few people get the scale right the first time.

Mixing the Values: Because the tinting strength of colors varies, you can't simply mix 50% white and 50% black to get value 5. Instead, you will need considerably more white than black. Use the gray scale printed here as a rough guideline and try to gauge your values by eye. The key values to start with are values 9, 5, and 1. Once these are correct, use them to mix the following values:

Value 7 (from value 9 + value 5)
Value 3 (from value 1 + value 5)

Finally, mix these values to get the remaining values:
Value 8 (from value 9 + value 7)
Value 6 (from value 7 + value 5)
Value 4 (from value 5 + value 3)
Value 2 (from value 3 + value 1)

Measuring the Paint: In making your gray scale, you may want to write down the proportions of white and black you use for future reference. One way to do this is to consider 1 portion as equal to ¼ inch of paint as it comes out of the tube. Of course, if the tube openings for your white and black paint differ, you must adjust for that.

Storing the Paint: Mix enough of each gray value for later assignments. This extra paint can be stored in empty paint tubes (available at art stores) or 35mm color film containers. Be sure to label the containers as you put paint in them.

Chroma

Chroma is the degree of intensity of a hue.

A change in chroma must not bring about a change in value. If, for instance, we take a hue at value 5 and wish to change its chroma, we mix it with a neutral gray of the same value. Let's take cadmium red light, which has a value of 5 and is at maximum chroma when it comes out of the tube. To change its chroma, use a neutral gray that is also value 5. The percentage of this neutral gray (value 5) added to the cadmium red light (value 5) determines the chroma of that mixture.

Although the number of steps between a full-strength hue and a neutral gray is unlimited, for practical purposes we will use two intermediary steps: medium and weak. Thus, with cadmium red light, we would have:

2 parts Red Value 5 + 1 part Gray Value 5 = Red Value 5/Medium Chroma

1 part Red Value 5 + 2 parts Gray Value 5 = Red Value 5/Weak Chroma

Note: In the Munsell system, the hue is listed first, then the value (with a slash), then the chroma. Thus, R 5/6 refers to a red with a value of 5 and a chroma of 6.

ASSIGNMENT

Make a simple three-value chroma chart for a particular hue, using only values 3, 5, and 8, and showing strong (maximum), medium, and weak chromas. (If you are more ambitious, make a full nine-value chroma chart, showing strong, medium, and weak chromas). Repeat this process with each hue on your palette.

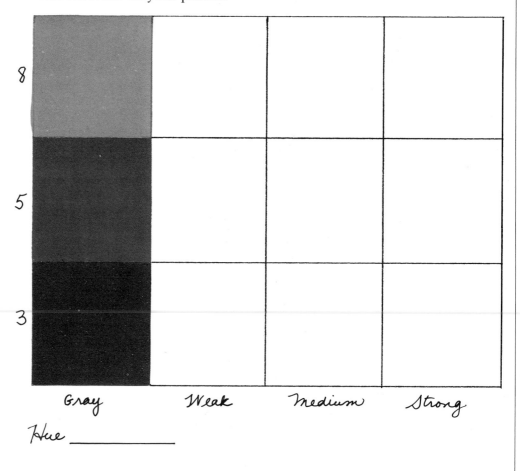

8

5

3

Gray Weak Medium Strong

Hue _____

Mixing the Paint: Use the mixing chart below to determine how to lighten or darken a hue. Let's take cadmium red light, which comes out of the tube at value 5. To get value 8 for cadmium red light, add white and measure it against value 8 on the gray value scale. For value 3, make a combination of 90% alizarin crimson and 10% burnt umber, add this to the cadmium red light and measure this against value 3 on the gray scale.

TUBE COLOR	HOME-LEVEL VALUE*	ADD TO LIGHTEN	ADD TO DARKEN
Cadmium Yellow Light	9	White	Raw Sienna to Value 4; Raw Umber to Value 1
Cadmium Orange	7	White	Burnt Umber
Cadmium Red Light	5	White	90% Alizarin Crimson plus 10% Burnt Umber
Alizarin Crimson	1	White	Black**
Viridian	1	White	Black**
Cerulean Blue	4	White	Black
Ultramarine Blue	1	White	Black**
Yellow Ocher	6	White	Raw Umber
Raw Sienna	4	White	Raw Umber
Burnt Sienna	2	White	Burnt Umber

*Be sure to check the tube color values against your neutral gray scale as colors may vary from brand to brand, or even in the same brand.

**Because these hues are already value 1, they should not be darkened in a painting as nothing should be below value 1 or above value 9.

Special Tips: When you make your chroma charts, first cut pieces of paper into rectangles about 2 × 5 inches. Paint these with your gray values so that you have nine pieces of paper, each painted a different value. Then, when you mix your colors for the chroma charts, put the color on the corresponding gray value to see if it is correct. If it "sinks" into the gray value when you squint, the value is correct and you can put it in the right place on your chart. It also helps to add a drop of cobalt drier to each color to speed the drying time.

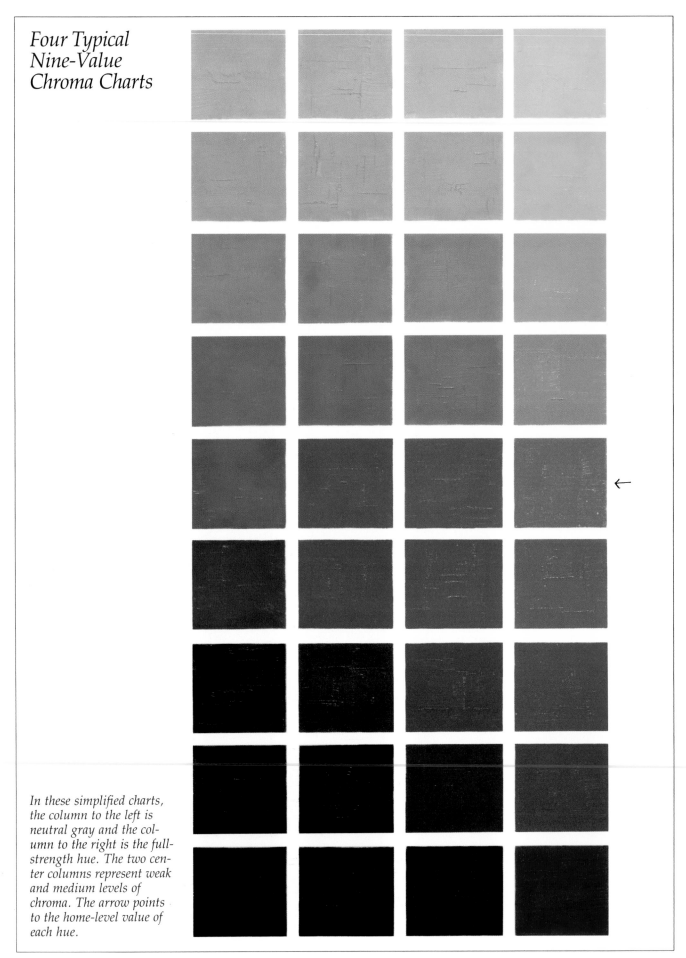

Four Typical Nine-Value Chroma Charts

In these simplified charts, the column to the left is neutral gray and the column to the right is the full-strength hue. The two center columns represent weak and medium levels of chroma. The arrow points to the home-level value of each hue.

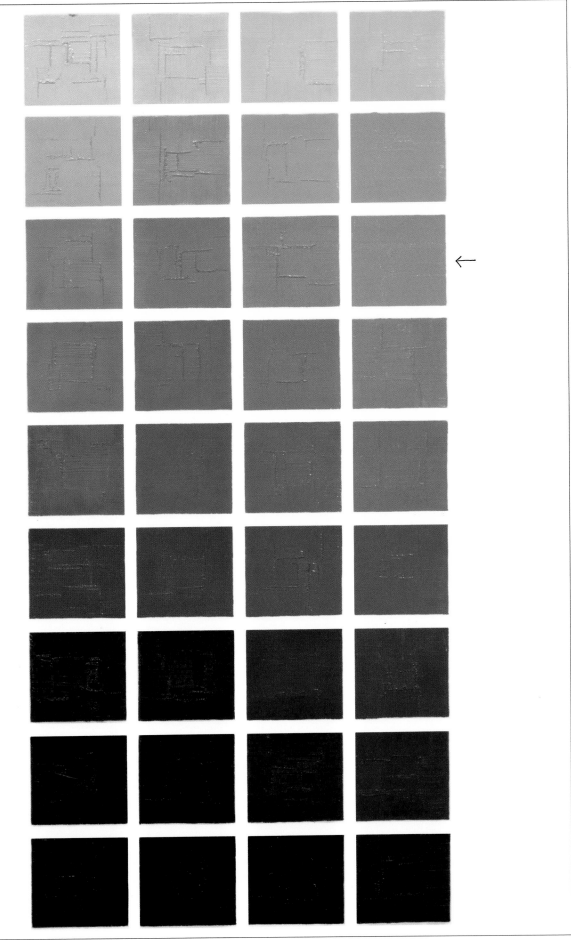

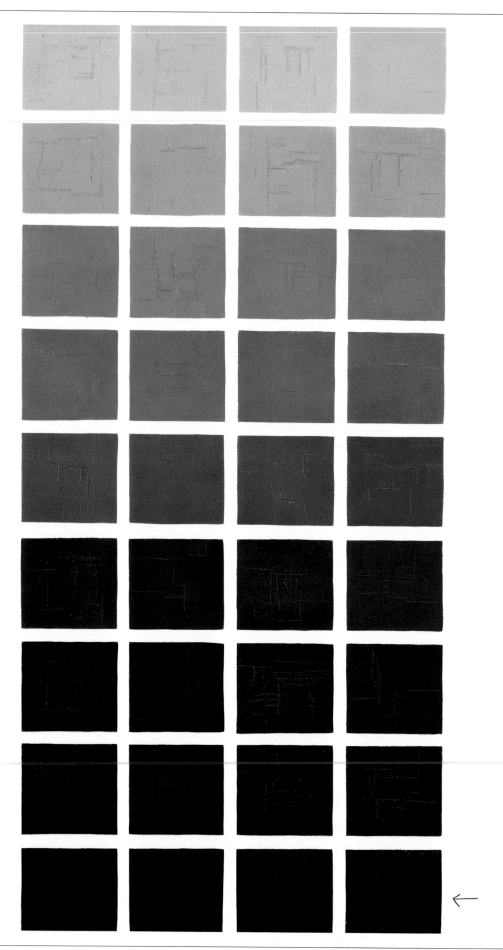

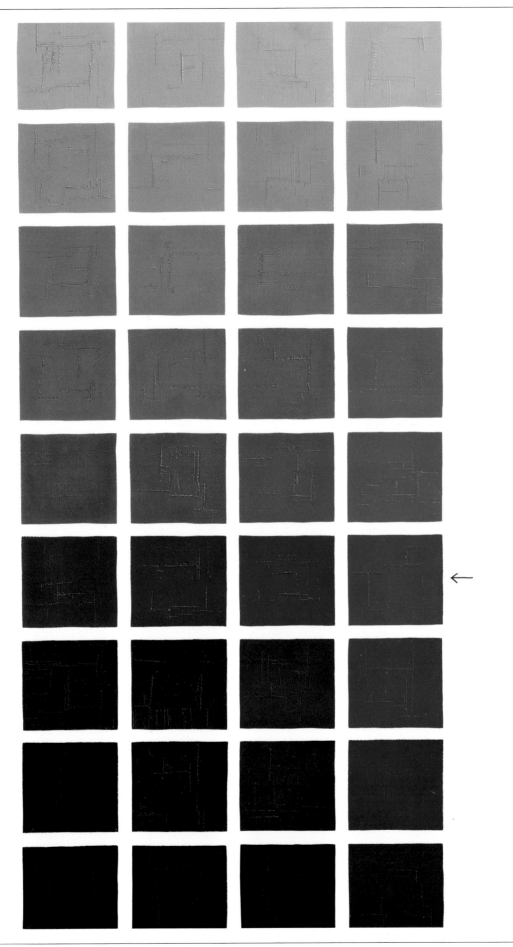

Color, Light, and Form

Different lighting conditions have different effects on value and chroma. In painting the model, try to use form lighting, where the lighting is at an angle that best reveals the form. You should, however, observe what happens when the light is from the front or back, or when it just hits the rim of an object.

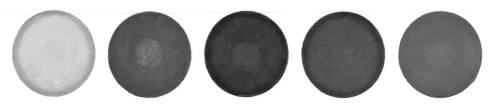

These balls are shown in front lighting. The edges are painted two values darker than the rest, and the chroma is strongest in the center. The examples below show one hue—yellow-red (the flesh color)—under different lighting conditions.

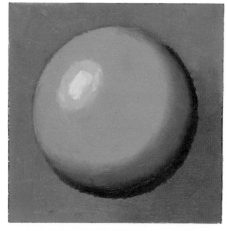

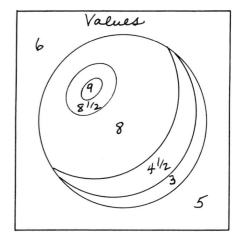

You can see how form lighting reveals the form. The strongest chroma is in the light, and it gets weaker in the shadow.

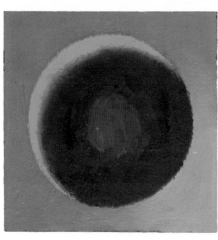

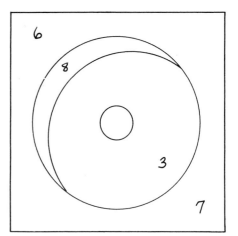

In rim lighting, the chroma is weak in the light and even weaker in the shadow. A touch of stronger chroma in the center, however, helps to clarify the form.

In backlighting, the overall chroma is weak, but again the chroma is stronger in the center to clarify the form. Note that the edge is one-half to one value darker than the form.

At times you may want to keep the chroma strong while you change the value of the color. To lighten or darken a color without losing intensity, you can move around the color wheel as shown, using the home level (maximum chroma) of each color. There will, however, be some change in the hue.

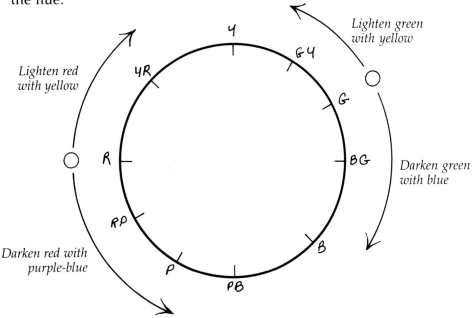

Lighten green with yellow

Lighten red with yellow

Darken green with blue

Darken red with purple-blue

When you paint, try to change only one factor at a time. To see which factors influence our perception of three-dimensional form the most, paint these boxes according to the instructions. Do this in several different hues.

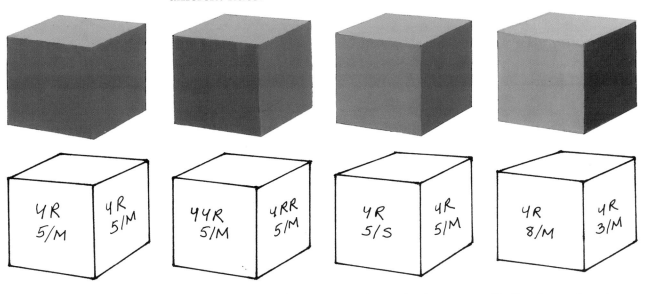

Start with your hue at value 5 and a medium chroma. As you can see, without the top, there would be no definition of form.

Change the hue on both sides, but keep the value and chroma the same. With this change, there is only a little clarification of the form.

Now change the chroma on the front to make it strong, but keep the value and hue constant. Here there is a 20% definition of the form.

Finally, change the value on both sides as indicated, but keep the chroma and hue constant. Changing the value in this way gives an 80% definition of the form.

In painting, remember that it is the mind that really sees—the eye only looks. In other words, you can see only what the mind knows. Don't try to copy nature or the model. Instead, learn the theory of nature and the procedure for translating it. Paint by principle only.

The mind is selective—you can focus on only one object at a time. You must look at things in the correct order, from the big things to the smaller ones. Also, because we see with two eyes (binocular vision), you must have soft edges in painting.

In moving from the scale of nature into the scale of paint, you must *adjust* the values of nature into the values of paint.

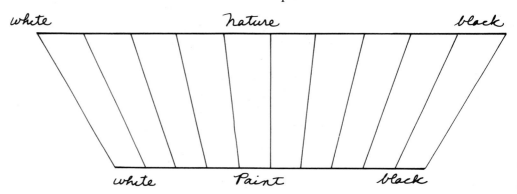

There are two ways to paint:
1. Direct painting (where you create the form by the direct application of pigment, without scumbling or glazing).
2. Suggestion (where you suggest the form through glazing or scumbling).
When you're learning to paint, try to paint the form directly. Don't take the easy way out and simply "suggest" it. Also, as a beginner, remember that your paintings are for study only. Don't worry about a finished look. The important thing at this point is to learn.

WORK IN MASSES

In the beginning, mass your paint. If you keep the masses simple, you'll learn to paint more quickly. Put in the large masses first. Then, once they're correct, put in the smaller masses.

Paint the same way you draw:
1. In blocking in the figure, first define the action.
2. Once the action is established, begin to model the forms.

Start with the background. The background is usually a flat value with a cast shadow (from an object in front of it).

Next consider the first—the largest—form of the object or model. With a round form, it is the light and shadow that give the appearance of roundness. There should be two values in the light and one value in the shadow. Overall, the model has three values in the light and one value in the shadow.

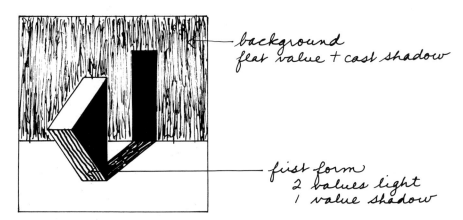

background
flat value + cast shadow

first form
2 values light
1 value shadow

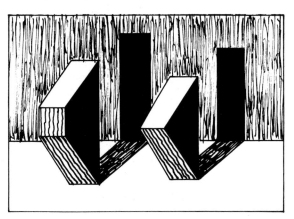

whole model
3 values light
1 value shadow

Note: As you paint, you want to keep the background back—away from the figure. To do this, make sure the lightest lights are on the figure and the background remains simple, with a generally flat value and very little detail. Soften the edges of the figure to create an atmospheric effect.

There are four basic steps to painting:

1. Wash-in: Establish the basic drawing, values, and edges in a monochrome painting (in raw umber).

2. Lay-in: Repeat the wash-in with opaque pigment in flat color. Set up the complexion of the model and concentrate on your drawing, values, and edges.

3. Painting: Develop the lay-in by painting directly into wet paint. (Mix a few drops of oil of cloves into the colors on your palette to keep them moist while you paint.)

4. Finish: Make the final touches, adding highlights and modeling subtle details.

Materials

In learning to paint, use the Reilly palette rather than a free palette (see the discussion and photographs on pp. 108–109). It's a mistake to include too few colors on your palette. But you don't want too many either. Use only the colors you will need. Remember that with the principal hues in the Reilly/Munsell system—yellow, red, purple, blue, and green—you can make any color in the world.

(see the discussion and photographs on pp. 108–109)

BRUSHES

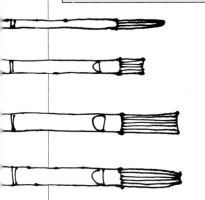

While you're learning, paint only with filbert or flat bristle brushes. Sable brushes are too soft and pick up too much paint from the canvas.

You'll also need a wash-in brush (a cutter or varnish brush about 1 or 1½ inches wide). And buy a fan brush. Although you won't use this very often, you'll need it for some details.

Always use the largest brush you can for the area to be painted. It will give your work a more professional (and less "picky") look.

To clean your brushes:
1. Squeeze out the excess pigment.
2. Wash the brush in mineral spirits two or three times.
3. Wash the brush with soap and water.
4. Rinse the brush with lukewarm water.
5. Wipe the brush over a bar of soap— in both directions.
6. Shape the brush with your fingers.

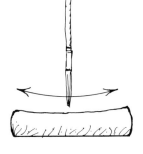

Use a palette knife only for mixing your paint. A trowel type of 3 or 4 inches is a good size.

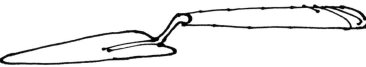

MEDIUMS

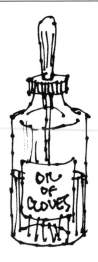

To start with, you'll want the following mediums:

Linseed oil: It's an absolute must as a painting medium. Buy a good grade.

Turpentine: Use it to paint with. Buy a good grade.

Mineral spirits (Varnolene): Use this only to clean brushes.

Oil of cloves: This allows you to keep the paint moist while you're working. Use one or two drops to an inch of paint (the amount depends on the drying speed of the paint).

Stand oil or sun-thickened oil: These are good secondary painting mediums. They dry with a gloss.

Cobalt drier: To speed drying time, mix one or two drops into your tube colors with a palette knife and then just paint as you ordinarily would.

Retouch varnish: Use this to restore the gloss to dull spots on your canvas, if needed.

Brushstrokes

Skill with a brush is very important in painting. With practice and experience, your brushstrokes will become a kind of personal handwriting. But first you must learn the craft of painting with a brush. Practice the different strokes here over and over until they are thoroughly familiar.

There are three main ways to apply paint with a brush:

1. The Stroke: Practicing the stroke is the best way to learn how to paint. Don't just make straight strokes—let them flow. Try varying the thickness of the stroke, from broad to narrow. And remember, just as with lines in drawing, every stroke must come from somewhere and go somewhere.

2. The Daub: The Impressionists often used this type of brushstroke. The size of the daub can be large or small, but once the pigment is put on the canvas, it must not be touched or blended. You can overlap one daub with another while both are still wet, or you can wait until the first daub is dry.

3. The Smear: Where soft edges are needed, you may want to smear the paint. Pick up some paint with your brush and literally rub it into the canvas. Use either a large or small amount of paint, but once the paint is applied to the canvas, don't blend the colors too much.

The ridges of paint left by your brushstrokes can enhance your painting, or they can get in the way.

When the ridges of paint are against the source of light, they will look lighter because the light reflects off the brushstroke.

When the ridges of paint go with the light source, they will look normal.

When you start, the best way is to make your brushstrokes go with the form.

The wash-in is an initial monochrome painting, done in raw umber. Its purpose is to solve all the problems of drawing, values, and edges. It also enables you to get rid of the whiteness of the canvas and to set up the correct atmosphere.

Doing a wash-in is particularly helpful when you are learning to paint because it allows you to solve drawing and basic value problems before you become involved in brushwork and color. When I worked in Reilly's class, I always did a wash-in first, but frankly it never appealed to me. As I gained experience, I started to work in full color right away. Today, the closest I come to a wash-in is to thin my color with turpentine in the first stages of painting.

Nevertheless, while you're learning, it's a good idea to start with a wash-in. I've included two demonstrations here to show you two different procedures you can use. The first—of a female model—begins with an ink drawing; the second—with a male model—starts out with the direct application of paint to the canvas.

MATERIALS

Before you start, be sure you have these materials:

A stretched, cotton duck canvas. (Later on, when you're more experienced, you may prefer to use linen canvas.)

A painting medium of one-half linseed oil and one-half turpentine. If, however, you find the paint dries too fast, increase the amount of linseed oil, or even use it full strength.

Raw umber paint. Raw umber is used because it does not bleed. Burnt umber, on the other hand, bleeds—meaning that the paint will eventually come through any paint you apply over it.

Cheesecloth. Use this to wipe out the raw umber when needed.

A cutter or varnish brush (1 or 1½ inches). This brush allows you to apply the paint in broad strokes.

Starting with an Ink Drawing

If you do not feel confident enough to draw directly with your brush on canvas, try the following procedure.

1. Sketch the Model

With a piece of charcoal, sketch the model on the canvas. Try to get the correct proportion and the main action. Do not, however, attempt to draw details at this stage—just indicate the main features.

2. Reinforce Your Drawing with Ink

Use a nonbleeding felt nib pen or a small watercolor brush to redraw your charcoal drawing with diluted India ink. Don't use full-strength ink, or you'll end up with too black a statement. Again, don't put in too many details—concentrate on the main abstract shapes. Once this drawing is complete, wipe off the charcoal from your sketch.

3. Add a Coat of Linseed Oil

Using your cutter or varnish brush, coat the canvas with linseed oil—first in a horizontal direction and then in a vertical one. Wipe off the excess oil with cheesecloth.

4. Cover the Canvas with Raw Umber

Mix raw umber with some painting medium (one-half linseed oil and one-half turpentine). Using the varnish brush, cover the entire canvas. With a piece of cheesecloth, wipe out the umber-covered canvas to value 3, which is the value of the model's shadow. If your initial coating is lighter than value 3, darken it with more raw umber. Your black drawing will still be visible through the value 3 coat of raw umber.

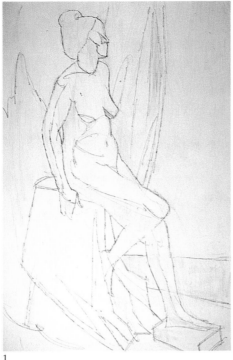

1

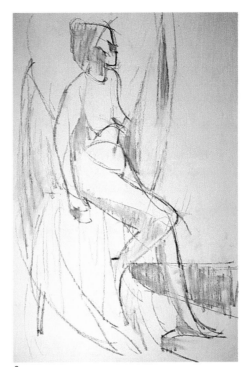

2

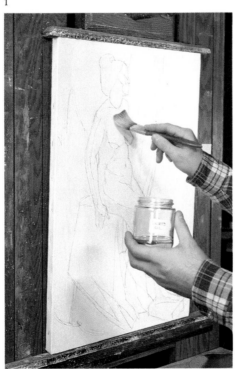

3

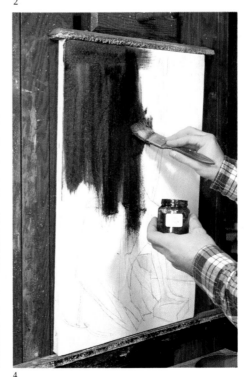

4

5. Wipe out the Lights

Now use the cheesecloth to wipe out the light areas on the figure and the drapery she is sitting on. Here I wiped the lights to value 7, which was typical of the lighting conditions in Reilly's class. (The values given here are only guidelines; in different lighting conditions, your values may differ.)

6. Wipe out Darkest Lights

Look for the darkest light areas in the background and wipe these out to the correct value.

7. Wipe out Lighter Lights

Now wipe out the lighter areas on the figure to about value 8.

8. Add Darker Areas

Using the varnish brush and raw umber, put in the darkest light on the model. Also add shadows, if needed, to the folds of the drapery (to the right of the figure here).

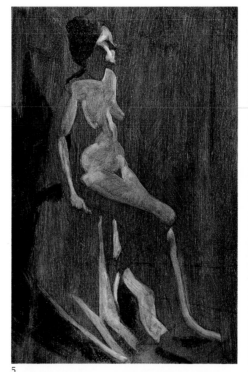

5

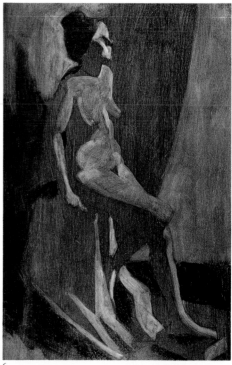

6

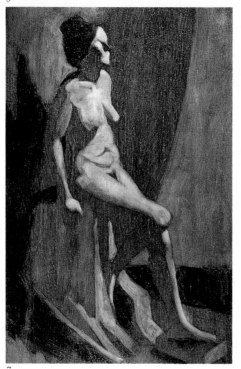

7

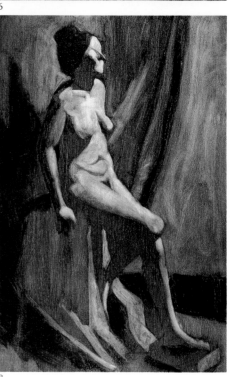

8

9. Soften Edges and Wipe out Center Lights

Soften all edges, both inside and outside the figure. These edges together with the halftones, will define the form. Also wipe out the center lights, which are always in the middle of the light areas. These center lights should be about one value lighter than the light areas. Don't, however, worry about the highlights yet—leave that until the very end of the painting stage.

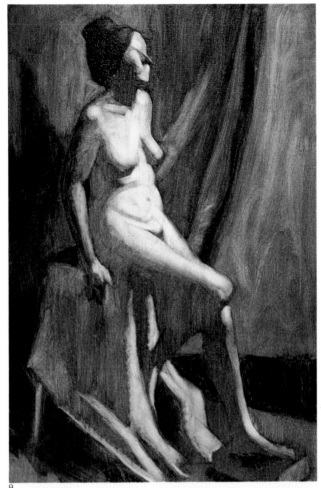

9

Detail of Finished Wash-In

This closeup of the head shows the degree of finish I use for a wash-in. You may carry the wash-in to any degree of finish you want, but remember the main purpose of the wash-in is to set up the underlying drawing and values. The important thing is to practice. The more you practice, the more control you'll achieve.

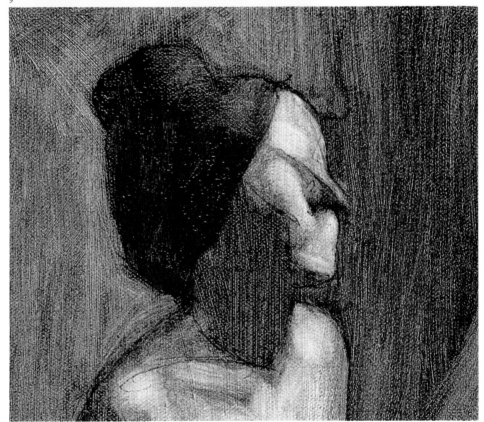

Working Directly

Once you have confidence in your drawing ability, you can do a wash-in the way we did in Reilly's class—that is, with no preliminary drawing before applying raw umber to the canvas. To start, coat your canvas with linseed oil as described in step 3 of the previous demonstration. After this step is complete, cover the canvas with raw umber as described in step 4 of the previous demonstration. Remember that if the coat of raw umber isn't dark enough—value 3—you should add more raw umber. Now continue with the following procedure.

1. Outline the Lights
Draw the outlines of all the lightest sections of the picture with the pointed end of a paint brush (you can sharpen it with a pencil sharpener) or the edge of a palette knife. Leave the shadow areas alone.

2. Wipe out the Lights
Using your cheesecloth, wipe out the light areas to about value 7. Also paint in the darkest areas with more raw umber.

1

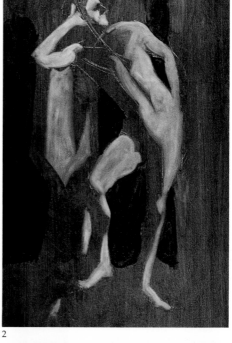

2

**3. Wipe out
Darkest Lights**
Now wipe out the darkest lights. Here they are in the background to the right, in the foreground, and on the drapery.

**4. Wipe out
Lightest Lights**
Return to the figure and wipe out the lightest lights to about value 8. Here I accidentally wiped out the belly button, which I then restated.

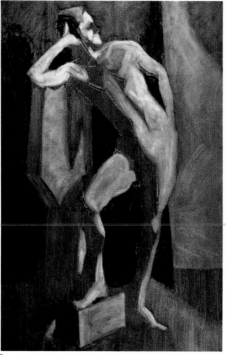

3

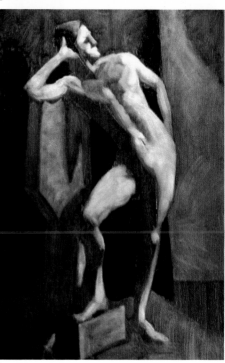

4

5. Wipe out Reflected Lights and Add Halftones

Look for the reflected lights and wipe them out. Also add any needed halftones.

6. Put in Accents and Soften Edges

To bring out form, add accents where needed. Here they were put in to separate the torso from the drapery and the foot from the floor. Also soften all the edges, which—together with the halftones—will define the forms.

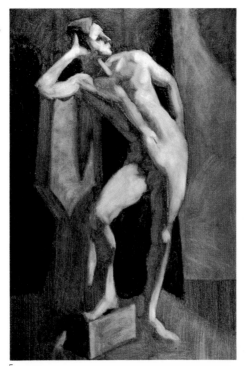

5

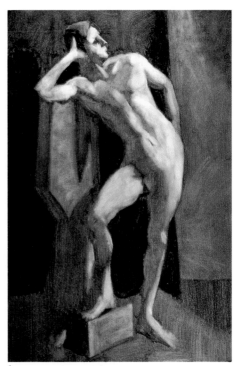

6

7. Wipe out Center Lights

Locate the center lights, which are in the middle of the light areas, and wipe them out. Make them about one value lighter than the surrounding lights. You can also put in the high-lights, although this is best left for later, during the painting stage.

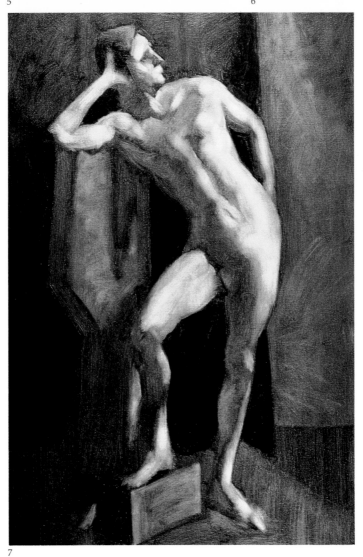

7

Lay-In and Painting Stage

Once you've finished the wash-in, you're ready to begin working in color with opaque paint. This phase—called the *lay-in*—helps you set up the complexion of the model. Essentially, you repeat the steps of the wash-in—only this time in color. The lay-in evolves into the painting stage, where you add the halftones, develop the gradations and progressions, introduce the center lights and highlights, define the planes, and soften the edges. In the demonstrations on the next few pages, I've simplified Reilly's process somewhat, combining the lay-in with the painting stage, in a way that I believe is most helpful for beginners. The notes from Reilly's classes that follow the demonstration will help you develop your paintings even further.

Color Note

Before you begin the lay-in, make a color note. The color note—also called the *poster*—describes the overall complexion of the model and the main colors in the picture. It tells you what the colors in the finished painting will look like, showing the main hues, values, and chromas, as well as the position of the primary source of light.

Make your color note about 6 inches high, either in the upper section of your wash-in canvas or (if you're more advanced) on a separate canvas or board. It's best to make the color note while you're mixing your paints for the lay-in itself.

Don't complicate your color note with too many details. What you want is the essential information. Here are some guidelines:

Background: Decide on one flat light area and one cast shadow.

Drapery: Look for two light values and one shadow value.

Figure: Determine three light values and one shadow value.

COLOR NOTE DEMONSTRATION

Here you can see the two different ways of making a color note. For the female model, I painted the color note right on the canvas so it was constantly in front of me as I laid in the colors. For the male model, I decided to do my color note on a separate board. Although this is less handy as an immediate check on your colors, you may prefer it once you're more experienced.

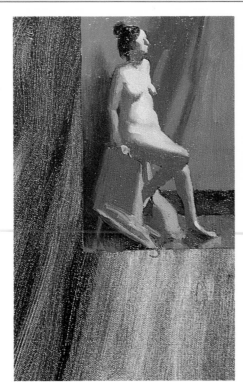

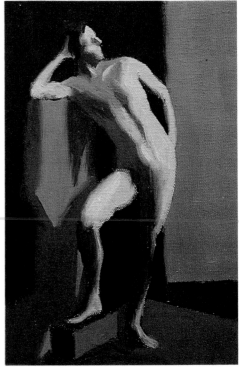

Painting Demonstration

After you've finished the color note, you're ready to begin working in color on your canvas. At the start work flatly, laying in broad average values in accordance with your color note. Always work from big to small, adding detail only gradually.

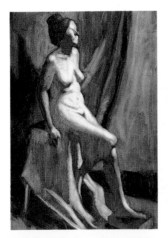
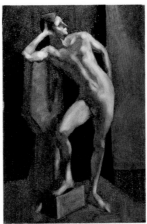

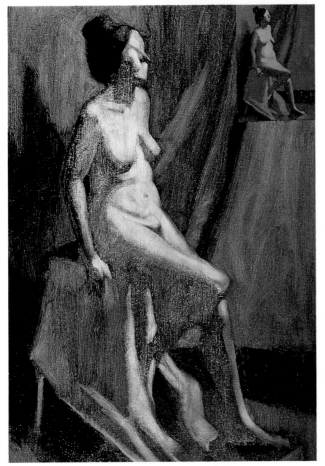
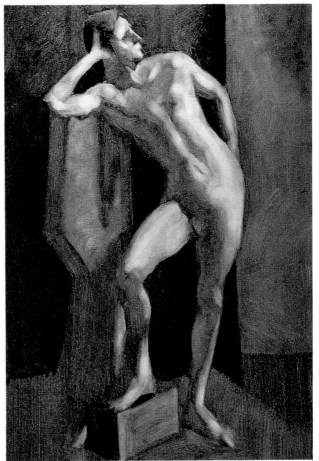

1. Put in Dark Accents

The first step is to paint in the dark accents. Compare this step with the final step of the wash-in (shown above). In the female I've painted in the darks in the hair, for the cast shadows, under the foot, next to the foot resting on the stool, on the lower left of the red drapery, and on the fold in the drapery just under the color note. With the male, I've laid in darks in the hair, under the foot to the left, and in the background.

2. Indicate Local Colors in Shadows

Now paint in the local colors for all the shadows—on the figure and drapery as well as in the background. The shadow on the average complexion is value 3, as you can see on the female model here. The male model, however, had such a light complexion and there was so much reflected light that I went up to value 4. By the way, while you're painting, it's a good idea to soften the edges when two wet areas of paint are next to each other.

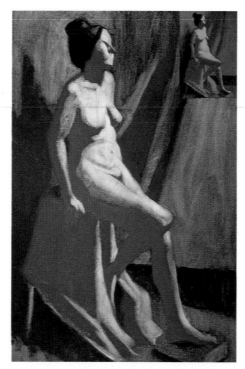

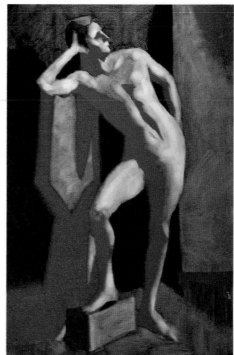

3. Paint in the Lights around the Model

The next step is to paint in the local colors for all the light areas in the background. Once this is done, put in the local colors in the light areas on everything except the model. It's important to paint the background first so that the model and objects in the middle and foreground can overlap the background colors. Be careful, though, not to "overmodel" or exaggerate the contrasts in the background—if you do, it will compete with the figure.

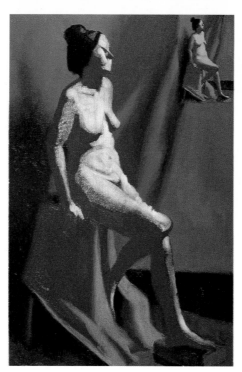

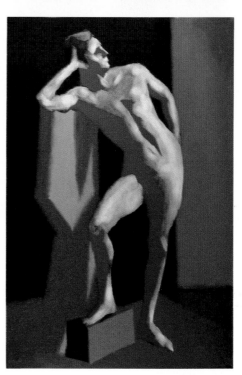

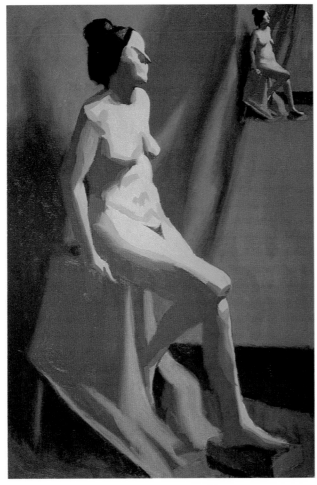
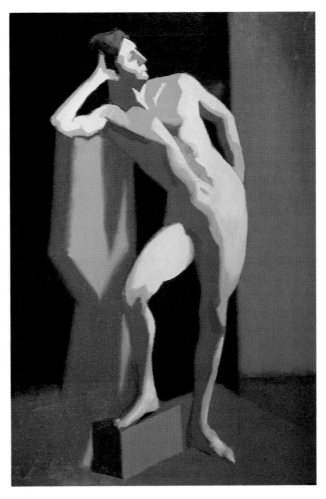

4. Establish Average Flesh Color and Halftones

Turning to the model, paint in the average local colors for the skin in the light areas. Normally, as on the female model here, this should be value 7. On the male model, because of his lighter complexion, I used value 8. With both models here, the lighting was from above, so the average local color dropped to value 6 on the female's legs and value 7 on the male's legs. After these local colors are in, add the light and dark halftones to the model. At this point just paint the halftones in flat areas—leave the modeling until the next step.

5. Model the Form with Halftones

Now you're ready to soften the edges of the halftones. First, brush the halftones into the light areas on the figure; then brush the shadows into the halftones.

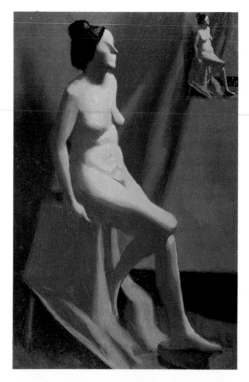

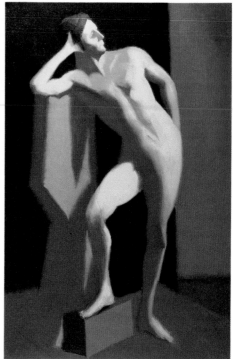

6. Add Center Lights

The next step is to paint in all the center lights, which are in the middle of the light areas.

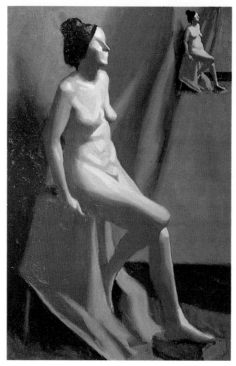

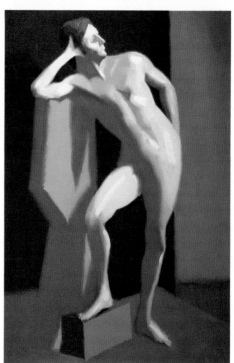

7. Put in Highlights

After you've softened the edges of the center lights, add the highlights. Notice that at this point I painted over the color note for the female model. I also added some red to her cheeks, nose, and knee to make them stand out. Then, by strengthening the chroma of her thigh with some orange, I brought her leg forward. On the male model I strengthened the chroma at all the joints by adding a small amount of red. At the joints the blood vessels are closer to the skin's surface so the chroma should be stronger there.

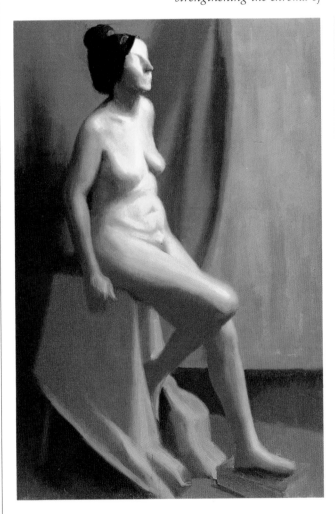

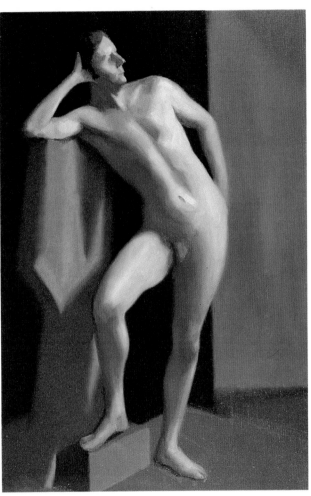

To gain a better understanding of the steps in painting the model, read the notes from Reilly's classes on the following pages. In the beginning concentrate on getting the drawing, color (especially value), and edges right. Don't worry about finishing your painting. If you think something is wrong with your painting, correct it as quickly as possible. Always restate the big things first.

Complexion or Flesh Color

To determine the complexion of the model, squint your eyes and look for the average value and hue of the skin on the torso. Focus on the largest area.

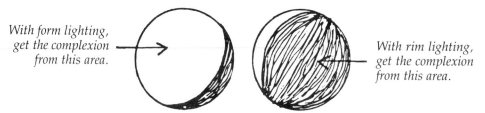

With form lighting, get the complexion from this area.

With rim lighting, get the complexion from this area.

The basic hue for the flesh is yellow-red (YR). If the model has thick skin, use yellow plus yellow-red (Y + YR) as there is less blood near the surface. For a model with thin skin, use yellow-red plus red (YR + R) as there is more blood near the surface.

KEEP THE LAY-IN SIMPLE

There are three basic types of skin color: light, average, and dark (black). The values, hue, and chroma are different for each, but the basic principles are the same. Look for three values in the light and one in the shadow.

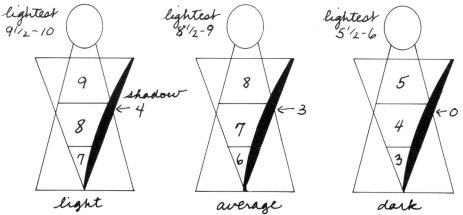

Remember that the value of the shadow stays the same against all three values in the light.

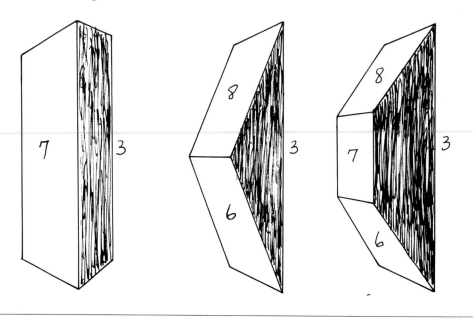

Make the halftones one and one-half values darker than the values of the light areas they are next to.

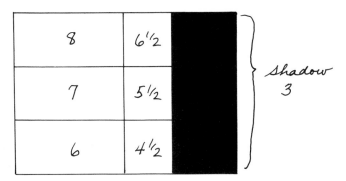

If you are unsure of a value when you are painting, check it against two other known values—one lighter and one darker.

Note that the chroma should be weaker in the shadow than in the light.

AVERAGE COMPLEXION CHART

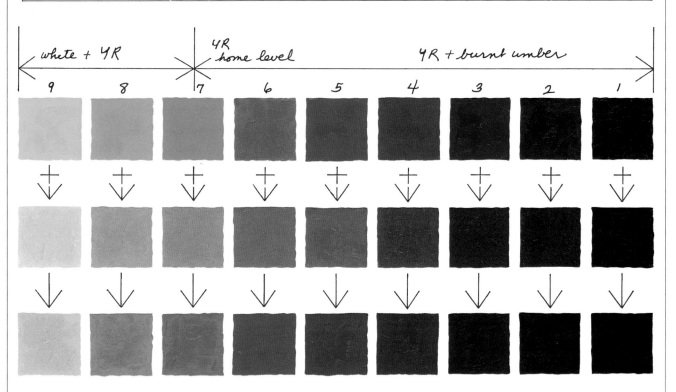

This chart illustrates how to mix your colors for the average complexion, which is based on yellow-red (YR), or cadmium orange. Essentially you add the light control (gray) of the corresponding value to the local color for each of the nine values. When the yellow-red is made lighter than value 7 (its home level), add smaller amounts of gray to get the same-value complexion color. The reason for this is that as you add more white to yellow-red, it becomes weaker in chroma and thus needs less gray. As the yellow-red becomes darker, moving toward value 1, add equal amounts of gray to get the complexion color.

The Effect

The *effect* is the lightest and largest area in the painting. You can think of it as a spotlight on a stage. It creates a center of interest.

There are three main kinds of effect in a painting:
1. Effect in hue
2. Effect in value
3. Effect in chroma

There are also three degrees of effect for each hue, value, and chroma:
1. Primary effect (the largest)
2. Secondary effect (smaller)
3. Tertiary effect (the next smallest)

The effect is always one-half value lighter than the local color it is within and thus gives added light to the model. The effect also gives the form its greatest volume and lends a brilliant look to the painting.

Remember that the effect always shows the direction of the light source. It is on the part of the form nearest the light; it is never near the shadow side of the model.

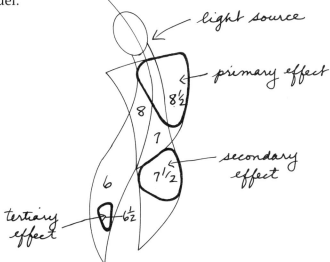

Keeping the shadows on the model the same value will augment the effect in the light areas. When the contrast is less in one area, the effect seems greater in another (an optical illusion). This principle also applies to areas of reflected light, where there is some variation in the shadows.

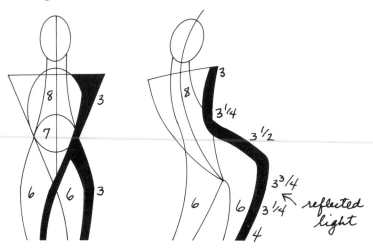

Keep in mind that as the light source is moved away, the effect decreases because the contrast between light and shadow decreases. In other words, the contrast is greater when the light source is closer.

Halftones

Halftones make an object turn, giving the form a feeling of roundness.

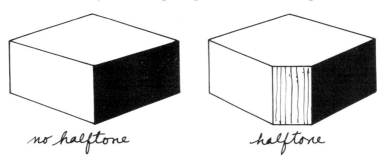

no halftone halftone

When you put in your halftones, make sure:
• the VALUE is correct.
• the SIZE of the area is correct.
• the PLACEMENT is correct.
• the EDGE is correct.

Don't overmodel your halftones or you will destroy the form.

There are two basic kinds of halftones:
1. DARK halftones—the transitions between light and shade.
2. LIGHT halftones—small dark areas within the light areas.

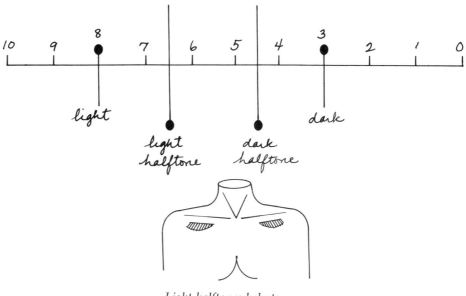

Light halftones help to
bring the underplanes out
in the light areas.

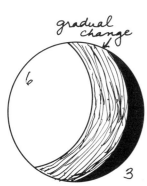

You can lay in the halftone in two ways:
1. With the light—and then pull the halftone into the shadow.
2. With the shadow—and then pull the halftone into the light.

Put the halftones in the smallest area possible. If the halftone is too wide, it will flatten the form. When the halftone does cover a relatively large area, make sure the change in value is gradual so that you can tell what the local color is.

Remember to keep the chroma of the halftone the same as the chroma of the light and shadow.

Gradation

Gradation is the degree of change across a surface. Its purpose is to enhance the effect of the light and to create a minor focal area.

First, make your gradation in VALUE, as this will have the most gradation. Then, look for gradation in CHROMA, which is less pronounced. Finally, check for gradation in HUE, which only occurs in some paintings.

In grading your values on a flat plane background, never grade more than one and a half values or your flat plane will look as if it is curved.

Remember that the gradation in value always shows the position of the light source.

- The closer the light source is to the background, the more gradation there will be on its surface. And vice versa: the further the light source is from the background, the less gradation there will be.
- A front light source shining on the background means there will be no gradation.
- Form lighting on the background creates one to one and a half value gradations.
- With an extreme side light (raking light), the background takes on a two- to three-value gradation. Be careful, however, not to make the gradation any more than this or the background will look round, not flat.

A point light source (like a light bulb) results in more gradation, while a diffused light (as on a hazy day) leaves less gradation.

The more textured a surface is, the bigger the gradation will be. Here the angle of viewing, or position of the viewer, is important.

local color
value 6

6 | 7½
4½ | 6

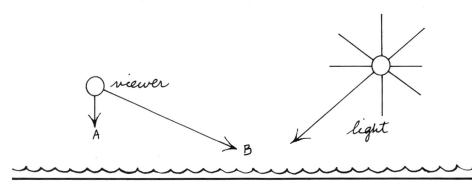

In position A, the viewer looks at the light part of the surface (sees the light side of the little grooves).

In position B, the viewer looks at the dark part of the surface (sees the shadow side of the little grooves).

With gradations in CHROMA, remember that the chroma becomes stronger when there is more light and vice versa. The strongest chroma will have a two- to three-chroma gradation.

If the background chroma is normal, the gradation can move toward either a weak or a strong chroma, but not both.

If your light source has a color, you need to account for gradation in HUE. North daylight is neutral in color, but an electric light bulb is yellow. In this case, add a middle-chroma yellow to the neutral grays you mix into your flesh colors.

normal chroma

6/N | 6/S
5/W | 5/N

Progression

Progression is different from gradation. Gradation is generally a gradual change, which occurs naturally across a form as it moves from near the light source to further away. Progression, on the other hand, refers to the projection of parts of the model in and out of the light, creating a sculptural, three-dimensional form.

Gradation essentially works across the surface, showing the passage of light and modeling the form in relatively even steps. Progression, on the other hand, moves in and out of the canvas, pushing the form forward or pulling it back. To give the feeling of progression, you need to work with contrast and hard vs. soft edges.

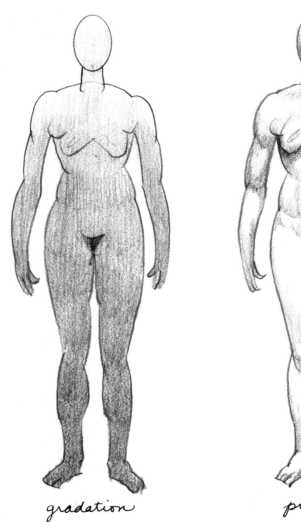

gradation progression

Progression can be in:
- VALUE (light vs. dark)
- CHROMA (strong vs. weak)
- HUE (complementary colors)

Both gradations and progressions start as simple statements. Build the changes (the details) into them gradually. Never make gradations or progressions more important than your main statement of light and shadow.

The greatest progression occurs where the contrasts are greatest. Add more detail to this area to make it stand out. If the contrasts are not pronounced, indicate progression with the edges. Hard edges will come forward; soft edges go back.

Make the relation between the model and the background enhance progression. Blur the edges as the model recedes into the background, but use hard edges where the model projects forward. Strong chroma on the model will make the figure come away from a weaker-chroma background.

Center Lights and Highlights

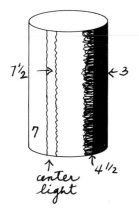

The center lights help to define the form in the light. Put them in the middle of the light area, slightly toward the side of the light source. Make the center light one-half value lighter than the form it is on, but keep the hue and chroma the same.

A center light is *not* a highlight. A highlight is put in the center of the center light and is one-half value lighter than the center light. The highlight has a hard edge on the side of the light source, but all the other edges are soft.

The smaller the form, the smaller the center light.
The larger the form, the larger the center light.
Also, the larger the form, the lighter the center light.

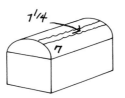 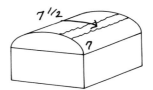 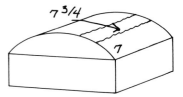

Center lights only occur on round forms. Square forms do not have a center light.

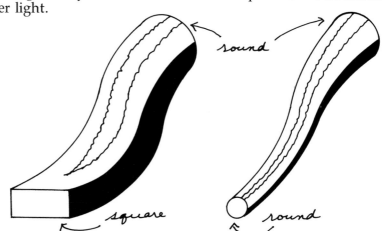

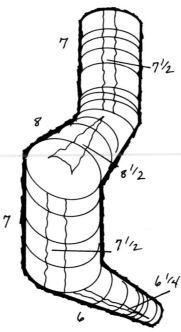

The center light has the greatest area on an upright form and very little area on an underplane. When a form is slanting or foreshortened, don't put in the center light until the end. Start with center light at the corner (e.g., the knee) and grade it back until it disappears into the foreshortened form (e.g., the thigh).

How you paint the center light is different for different parts of the body.

With the ARMS and LEGS: *Make sure the shape of the form is correct before adding the center light. Don't put the center lights on the large form. Instead, place them in relation to the action of the small forms. Note that the center light takes the shape of the form it is on.*

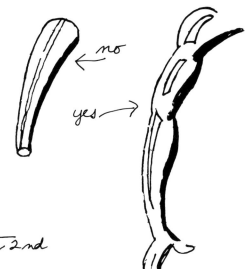

With the TORSO: *Always make the center light go with the action. Put the center light on the big forms first, then on the smaller forms like the breasts.*

Add *highlights* only at the very end (if at all). The highlights go on the corners or in the center of a light (as on the torso). Always relate the highlight to the light source, and make sure it goes toward the hue of the light source. Also relate the highlight to texture—a very rough texture has almost no highlight, while a smooth texture has a stronger highlight.

The highlight is in the shape of a comet. It has soft edges on three sides, but a hard edge on the side of the light source.

Remember that the highlight on dark skin will look lighter than it really is. The highlight is one value lighter than the skin's value and one-half value lighter than the center light.

NOTE ON REFLECTED LIGHT

Reflected light is mainly in the shadow. It is lighter than the shadow but never as light as the halftone. In fact, it may reflect hue and chroma more than value.

The shape of the area of reflected light goes against the form. Its color is usually on the warm side.

When you are painting indoors, an object reflecting light must not be more than 18 inches from the model. Outdoors, the object reflecting light can be as much as 10 to 15 feet from the figure.

Planes

In painting, always work from large to small. First, look for the planes of the figure on the large forms like the head or torso. Only later should you add the planes on the smaller forms like the nose.

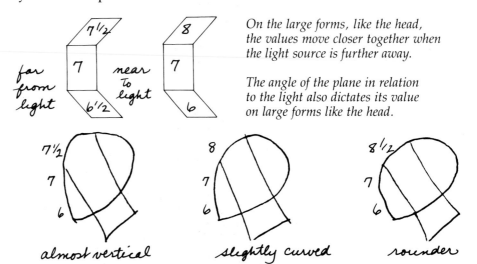

On the large forms, like the head, the values move closer together when the light source is further away.

The angle of the plane in relation to the light also dictates its value on large forms like the head.

almost vertical slightly curved rounder

To refine your painting, however, you need to articulate the small planes within the larger ones.

DEVELOP SMALLER TOP PLANES AND UNDERPLANES

When the TOP PLANE is in the LIGHT, make it one-half value lighter than the light. Remember that the top plane is not a highlight. Paint it with the action and then with the form. Soften its edges with a fan brush, but keep the edge of the top plane near the form harder. This hard edge should go with the action.

When the UNDERPLANE is in the SHADOW, do not develop it too much—the less you do in the shadow, the better. Do not make changes in the shadow more than one-half value. You can, however, make chroma changes without value changes.

When the UNDERPLANE is in the LIGHT, be careful not to make it as important as the top plane. The underplane here is one-half value darker than the light and small in area. All underplanes have soft edges.

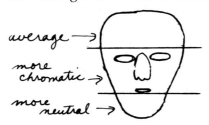

average →

more chromatic →

more neutral →

The underplanes on the head can be either more neutral or more chromatic than the model's average complexion.

When the TOP PLANE is in the SHADOW, there is less of a change than for underplanes in the shadow. The top plane is only one-fourth value lighter than the local color of the shadow.

To paint the top plane in the shadow, first put in the value 3 shadow with vertical brushstrokes. Then, using the same value 3, paint the top plane with horizontal brushstrokes. The light will reflect on the horizontal brushstrokes so they will look one-fourth value lighter.

An edge plane is never the main plane you are looking at, but it is different from a side plane. The edge plane is the actual edge of a form. It can be on the top, side, or bottom of a form.

Edge planes are best defined on a matte surface like the skin. Do not put edge planes on shiny surfaces like glass or silk.

The value of the edge plane is the same as the main plane it's on. The chroma, however, becomes more neutral—it is usually two steps weaker than the chroma of the front plane. In this way edge planes make your painting look more colorful. Because they are more neutral, they make the chroma in the front plane stand out.

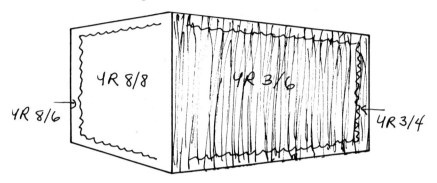

The narrower the edge plane is, the more neutral it is.

To see how the edge planes are affected by different lighting conditions, paint these balls according to the instructions.

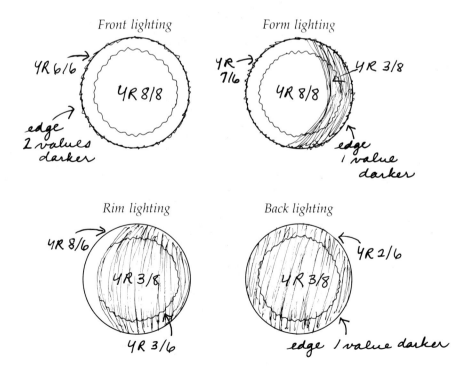

Hard vs. Soft Edges

Attention to the edges—hard vs. soft—makes for selective looking and adds interest to your painting. By varying the edges, you avoid a boring evenness of form and give life to your subject. The handling of the edges also gives you a chance for brilliant brushwork.

It's important that the edges are correct as you paint. If your edges are correct, your form will look correct. Begin with the outline, then paint the edges inside the form.

Make the edges slightly soft on round objects. If the edges are hard, the object will look flat, not round.

You can think of a scale of edges in your painting, from hard to soft to virtually no edge. Pay particular attention to the *big blur*—the largest soft-edge area in the painting. The big blur helps to create a sense of atmosphere.

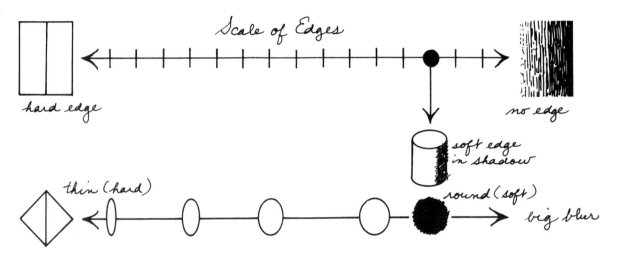

Remember these principles:
- Edges are softer in the shadow and harder in the light.
- The harder the edge is, the flatter the form will be. The softer the edge is, the rounder the form will be.
- The thinner an object is, the harder its edges will be.
- Always use a hard edge to define the main effect, or center of interest (where the light is strongest). Also use a hard edge whenever the local color changes.
- The closer the object is, the harder its edges are. The further away an object is, the softer its edges are.
- Hard edges make forms like bones project. The more projection you want, the harder the edge should be.
- Edges near the bone are harder; edges near the muscles are softer.
- Strong value contrasts make hard edges; with less contrast, the edges are softer.
- A point light source (e.g., a light bulb) creates harder edges; a diffused light (e.g., natural daylight) makes softer edges. Sunlight, however, gives a harder edge than moonlight.

Note: Your values may appear wrong if your edges are wrong.

When you begin painting, make all the edges soft. Then, as you develop the painting, start to vary the degree of softness on the model. Create a "big blur" in the areas of least interest, where you don't want the viewer to look. When the painting is about three-fourths finished, pay more attention to variations in edges. Look for lost and found edges, for where the form "disappears" and "reappears."

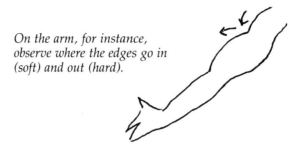

On the arm, for instance, observe where the edges go in (soft) and out (hard).

To make your edges soft, first paint the two values side by side, leaving a hard edge. Now zigzag through the wet paint with a clean brush. Then brush over the zigzag (vertically in this case). The larger the zigzag area is, the softer your edge will be.

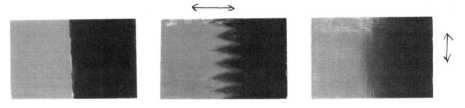

To see the difference between hard and soft edges, try this exercise. First paint an apple with soft edges on thin canvas or paper (A). Then paint another apple with soft edges on canvas board (B). Now cut out apple A, giving it a hard outline, and paste it on the canvas board (B). In this way you'll be able to see an apple with a hard edge next to an apple with a soft edge.

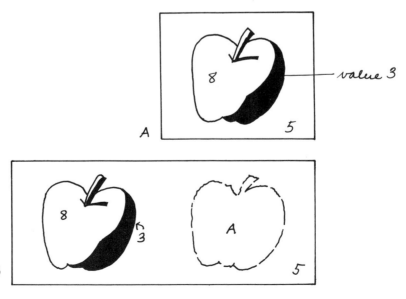

Finishing a painting is primarily a matter of bringing out the brushwork in the light areas and modeling the details. It's the time to make minor adjustments in the model's complexion as well as subtle hue and chroma changes. But don't lose sight of the painting as a whole. Always check to make sure your drawing is correct. And be careful, as you refine your work, not to obscure the main effect, action, and form.

A good procedure to follow is this:

1. Choose a main area (near the main effect) and bring it to a finish by putting in as much detail as you think necessary.

2. Pick a second area and bring it to a finish—but don't make it as finished as the main area.

3. Select a third area and finish it—but not as much as the second area.

BRING THE BRUSHWORK OUT IN THE LIGHT

Concentrate on the brushstrokes in the light areas—there should be no brushstrokes in the shadows. Think out each brushstroke before applying it. Remember that a brushstroke must come from somewhere and go somewhere. Decide on the direction and the size of the brushstroke before you put it down. Apply the brushstroke on the form, but make sure it goes with the action.

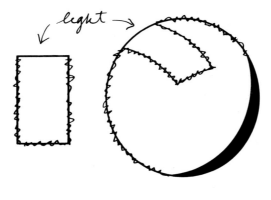

There are four sides to every brushstroke. Keep the hard edge in the direction of the light (so that edge is closest to the light).

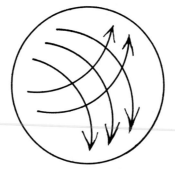

Use cross-strokes in the center of the light area of a form to bring out the form. Feather the ends of the cross-stroke and soften the edges.

Vary the thickness and thinness of your paint:
• The lighter the value, the thicker the paint should be.
• The darker the value, the thinner the paint should be. (But don't make it so thin that the texture of the canvas shows through.)

Model the small forms in the light, but only model the large forms in the shadow.

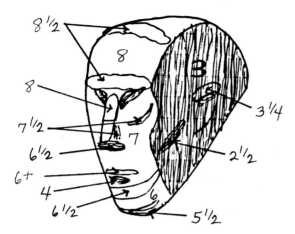

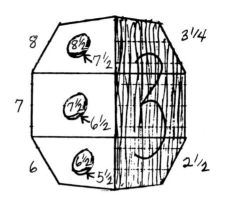

On a form like the head, pay attention to the values that define the planes and bring out the features in the light. In contrast, only put in value changes in the shadows if they are necessary to understand the form.

Remember that the values for top planes and underplanes differ according to the value of the main plane they are on.

To practice modeling small forms like those on the head, paint this ball in the values indicated. Use yellow-red (the complexion color) for the ball itself and make the background a value 5 gray.

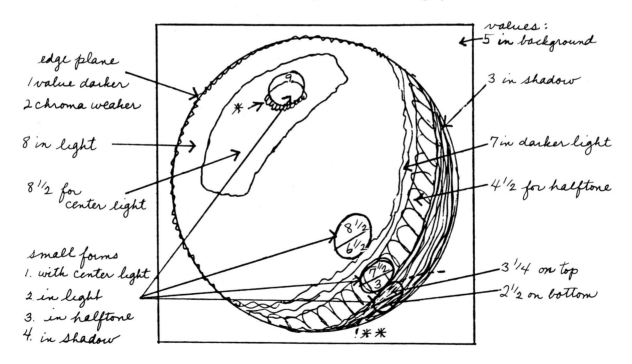

*For this small form in the center light, paint the top plane value 9, but don't paint an underplane. Instead, paint around the bottom of the form with a value of 8¾, which will give the illusion of an underplane.

**Along the dotted rule, paint in a reflected light.

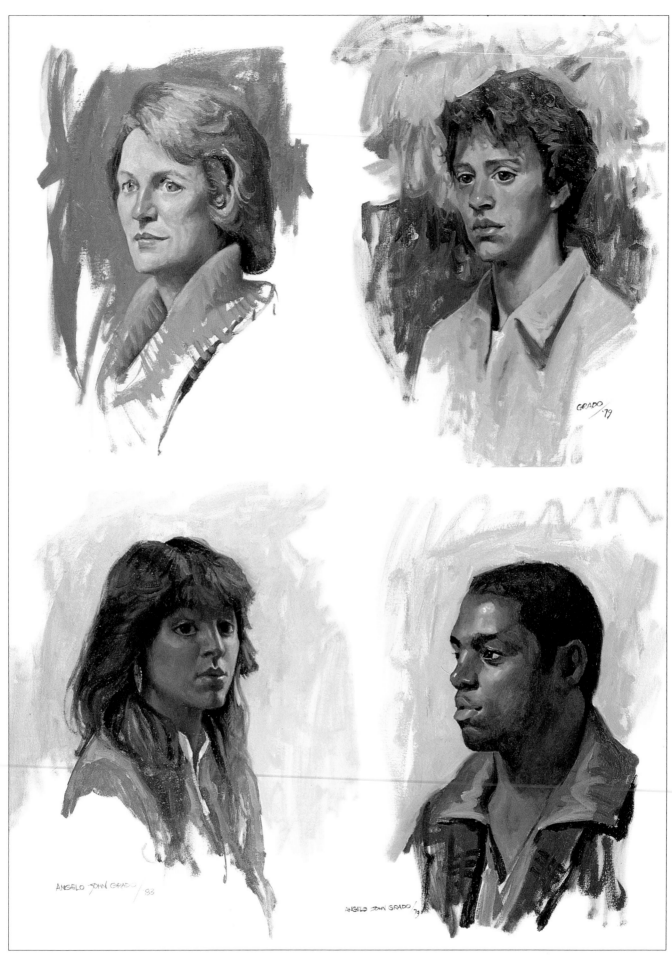

Beyond the Lessons: Developing Your Individuality

A good way to loosen up is to set yourself a time limit. These life-size (20" × 16") portrait sketches were done in under three hours. Try some yourself. Spend the first hour blocking in the head. Be sure to carefully measure four inches between the center of the pupils of the eyes and the chin. Also indicate the background and clothes. Once the head is blocked in, devote about a half-hour to each of the features. I say "about" because you should give your model a five-minute break every twenty-five minutes. No matter what state the painting is in, stop at the end of three hours and start another canvas.

The human brain is similar to a computer storing information. As you learn the craft of painting, this information is programmed into your computer-brain for later use. Extreme care must be taken to program only the "correct" information, because your brain will also store "incorrect" information.

After many years of painting, however, I found it was not necessary for me to consciously control every stage of my painting—as if only my computer-brain were in charge. I began to allow certain things to just "happen," without premeditation.

As you look at the gallery of my paintings in this section, you'll see how I've moved away from Frank Reilly's methods. At the same time all my work stems from the basic craft taught by Reilly. I like to think of my personal way of painting as an extension of what I have learned from all my teachers—not only Reilly, but also Robert Brackman and Robert Philipp.

For me, each painting presents a specific problem to be solved. Primarily these problems concern the light within the canvas and the tactile quality. By "tactile quality," I mean that the figures or objects on the canvas must not only look real, but they must also project a feeling of *being* real.

The captions for my paintings will help you to understand the thinking process behind my work. By showing you how I have developed beyond the lessons my teachers taught, I hope to encourage you to explore further on your own.

Choosing a Palette Arrangement

In Reilly's class we pre-mixed all our colors before we started to paint. I felt limited to these pre-mixed colors. It's true that with the Reilly palette you could match any color combination made with a free palette. But with Reilly's method, you had to think of all the colors you needed before you began to paint and then, more or less stay with them. There was little room for experimenting during the painting process.

In contrast, my other teachers—Brackman and Philipp—used a free palette and mixed their colors as their paintings progressed. At first I vacillated between the two methods, but now I use the free palette all the time. My paintings all begin freely, without pre-mixing. Only for the final stages of my tighter paintings do I pre-mix my paints. For looser paintings, I never pre-mix the colors. I find using a free palette more conducive to experimentation and thus more exciting.

THE REILLY PALETTE ARRANGEMENT

This palette is made of wood, which has been painted a value 6 gray and covered with glass. The top row has white on the extreme left, the nine values of gray, and black on the extreme right. Down the left side are the warm colors: cadmium yellow light, cadmium orange, cadmium red light, and alizarin crimson. On the right side are the cool colors: viridian, cerulean blue, and ultramarine blue. As each color is mixed, it is placed in the correct value column (i.e., blue value 6 is placed vertically under gray value 6). The different values for each hue are all placed in the same horizontal row (i.e., the nine values of blue form a line).

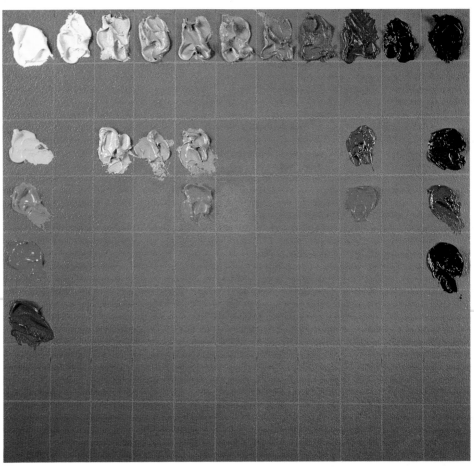

This palette can be made of wood or ¼" Masonite, with a coat of shellac to make it less absorbent. On the top row, from left to right, the pigments are white, cadmium yellow light, cadmium orange, cadmium red light, alizarin crimson, ultramarine blue, cerulean blue, and viridian. The vertical column under the white includes the earth colors (yellow ocher, raw sienna, burnt sienna, raw umber, burnt umber) and, at the bottom, ivory black. In using this palette as a free palette, I don't follow any particular system. When I use it as a controlled palette, however, I follow Reilly's method and pre-mix my colors, with one horizontal row for each color, always starting with the lighter value on the left.

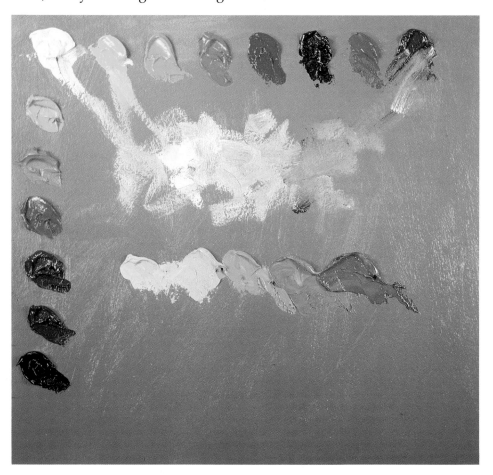

Loosening Up: A Demonstration

One of the joys of being an artist is that almost everything I see looks like a painting to me, even before the canvas is painted. I don't see leaves on a tree; I see brushstrokes of paint. It is similar to a composer who hears the music before writing it or playing it on an instrument.

Each canvas you paint should be a challenge. It would be boring to paint canvas after canvas in the same way, repeating the same subject matter. Of course, some repetition is necessary when you are learning. But even then there is a sense of discovery and accomplishment, of finding out how to do something and mastering the craft.

The demonstration that follows shows how I've modified the lessons from Reilly and my other teachers into a more intuitive approach. I decided to use a loose, impressionistic technique to paint the view from one of my studio windows. I have mentally painted this picture for the past twenty years, and although I have photographed the scene many times, it has never looked as good in a photograph as it does in my mind's eye. One bright, sunny day in July I thought the time had come for me to put my subconscious thoughts on canvas.

Preparation

I almost never make preliminary sketches before starting a painting, and because I was so familiar with this view, I didn't think I needed anything more than a small ink drawing I made several years ago. This sketch was used only to roughly indicate the composition. I had no preconceptions about what the painting should look like, except that it should be done in an impressionistic style. I wanted to paint this view without consciously trying to control how it developed. I would let whatever happened on the canvas happen, only becoming involved when things didn't work and a conscious decision had to be made.

I used an oil-primed canvas (20″ × 16″), which I had prepared a month earlier. At that time, to eliminate the cool grayish tone of the canvas and give it a slightly warmer look, I applied an additional coat of flake white with a touch of yellow ocher, using a palette knife. Then I worked the color into the surface with a no. 5 bristle brush for a slightly brushed impasto look.

After the canvas had dried for about a month, I lightly sanded the surface to even out any sharp impasto edges. I was ready to paint.

Establish the Abstract Pattern

1

2

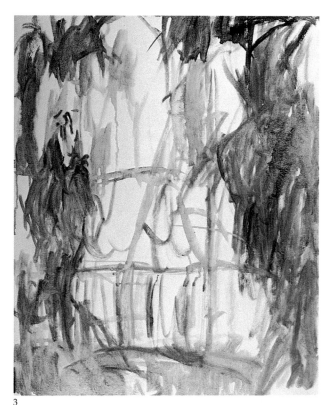

3

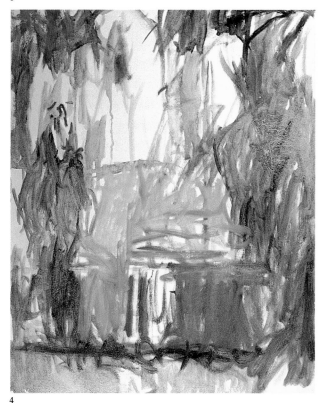

4

Step 1

Facing a blank canvas can be unsettling and I find that the sooner I make a mark on the canvas, the sooner things will begin to happen. Although during this first stage I may use only one or two colors, I put out my full palette of colors. Here I choose yellow ocher, a light color, to avoid making too dark a statement so early in the procedure. The yellow ocher is thinned with turpentine, which keeps the paint lean and makes it easy to remove with a rag if changes have to be made. I use a Grumbacher "Edgar Degas" series no. 3 bristle brush and make what may be no more than a few scribbles of color on the canvas. I don't really think too much at this stage —I just let things happen.

Step 2

Still using the no. 3 bristle brush, I add viridian to the yellow ocher and continue making marks on the canvas. At this point I really don't know how I want the painting to look, so I keep everything a little vague, again allowing things to happen. I have learned not to rush things, but to just let things develop.

Step 3

With a Grumbacher "Edgar Degas" series no. 5 bristle brush, I continue working with yellow ocher and viridian, both thinned with turpentine. I add more brushstrokes and notice that some shapes are beginning to develop. I don't try to preserve the indications of the fence or pole; I just keep adding brushstrokes of thinned paint to the canvas. Painting in this way does not mean one should be careless in the application of paint, but at the same time one should not be overly precise. I think the closest analogy is a musician improvising jazz. I'm not trying for correct values and hues, but just kind of sneaking up on them.

Step 4

Burnt sienna is now added to the yellow ocher and viridian. Using burnt sienna thinned with turpentine, I make the first strong statement in the lower right section of the canvas. The fence begins to disappear as I use more color and brushstrokes to cover the canvas. I'm keeping my eyes half-closed so that I do not see too many details. What I'm interested in at this point is the effect of the abstract forms before me.

Build the Forms

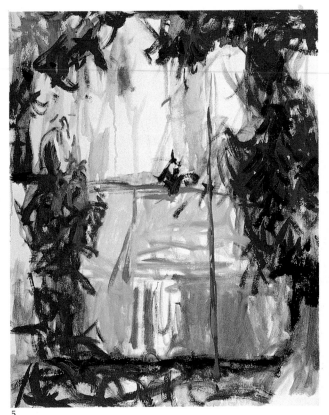

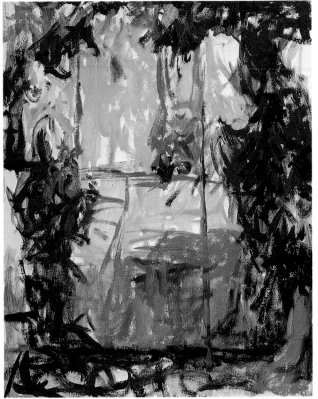

5

Step 5

I'm now using ultramarine blue with the yellow ocher, viridian, and burnt sienna. To make the colors lighter and more opaque, I add titanium white. My brush is still the no. 5 bristle. Usually I change brushes only when another size is needed. Sometimes I find myself using the same brush for the whole painting, cleaning it constantly and using it for all colors.

It's a habit I've gotten into and somehow it seems to work for me. I use almost no turpentine at this stage but apply the pigment thinly. The greens are made darker by using viridian full strength and also by adding ultramarine blue to the green. In some sections I apply lighter values of blue to the foliage to indicate the sky reflecting off the leaves.

6

Step 6

The forms in the painting are beginning to take shape. The doorway and wall of the building across the yard are indicated. Ultramarine blue is added to darken the burnt sienna. The building in the background is a beautiful, warm gray color, which seems to be a combination of light burnt sienna and strokes of the same value of ultramarine blue.

I'm still not trying to control anything too much; I really don't know what is going to happen. It is not uncommon for me to become very discouraged at some point, and it always takes a lot of determination to continue and complete the painting. I suppose it's part of the creative process or just the way I work. I've always admired and perhaps envied those painters who create canvas after canvas almost without effort, but it just is not my way and I've learned to live with it.

Step 7

The canvas is more or less laid in at this point. From now on, I must be a little more in control of what is happening. I lay in the large area of the doorway after selecting the correct value of cerulean blue and adding a little viridian. The large window areas are indicated with a mixture of raw umber and burnt sienna lightened with titanium white. The window to the right of the doorway is chromium oxide green mixed with yellow ocher. A darker value of raw umber and burnt sienna is used for the dark areas of the windows, and a combination of raw umber and ultramarine blue is used for the dark area of the door and steps.

I also roughly indicate the fence again, just to keep the feeling of the picture. Notice that the white fence is against a dark background while to the extreme left there is an interesting silhouette of a darker fence against a lighter background. It is little sections of landscape like this that add interest to a painting. Keep your eyes and mind open to these details!

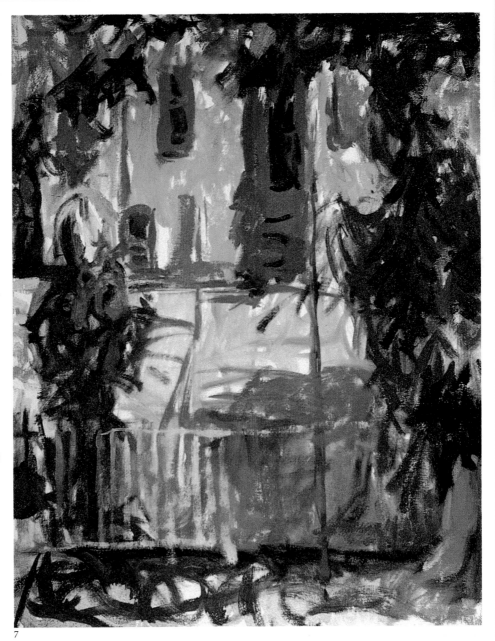

7

Take Control

Step 8

This stage of the painting is most important because I now take more control of the canvas and allow only the calligraphy of the brushstrokes to remain in flux. I now choose more specific colors and values, which will help to unify the picture. When you compare this stage (facing page) to the preceding one (below), you can easily see the greater degree of control.

In the upper left I start indicating the light areas of the foliage with a mixture of yellow ocher, chromium oxide green, and cadmium yellow light. Each brushstroke is placed on the canvas without blending so that an impasto effect is achieved. I then mix chromium oxide green to the middle foliage value, add a little raw umber to weaken the chroma, and brush in all the areas of foliage with that specific color. I also lighten the shadow to the left of the doorway.

The objects in the background should always be painted first so that the brushstrokes of the foreground objects can overlap the brushstrokes of the background objects. The most distant object in this painting is the building in the background. To convey its beautiful cement color, I mix a light value of raw umber and add the same value of burnt sienna. I apply this with a no. 5 bristle brush to most of the building. Then taking the same color, I add a little of the same-value cerulean blue and apply this color to the building, this time using broken brushstrokes. Once again I take the same color, but now I add a little cadmium orange and apply this to the same section of the building in broken brushstrokes. With each of these changes from burnt sienna to blue to orange, I change the color temperature but not the value.

In the middle section to the left, I start to indicate the light lawn. First I put in the cement color for the walkway in front of the building. Then I add chromium oxide green to suggest the lawn in that yard.

The walkway that leads directly back is the same color as the wall of the house, but because the walk is a top plane, I add a little white and a small amount of cadmium orange to make the color used on the walkway a little lighter and stronger in chroma. This will make the walk look more brilliant than the house and help the effect of sunlight.

The center section of this yard is not grass but dirt—which works fine in a painting, even though it is not pretty as a backyard. The color of the dirt is the same combination as the cement of the building and walk, only the dirt is a little warmer in color. I thus take the cement

color and add a little more burnt sienna and cadmium orange for the light areas of the dirt. To create a change in color temperature, I also use a mixture of this new color with cerulean blue of the same value.

In the shadow area of the dirt I use the same color combination, only darker in value. To make sure the value is correct I relate the shadow of the dirt to the darkest shadow of the foliage. Most shadows outdoors look darker than they are, so care must be taken to make them correct. The effect of shadow and sunlight is achieved more by a change in chroma than a change in value. If the shadow area is weaker in chroma and the sunlight stronger, it gives the effect of a bigger jump in value.

For the darkest areas of dirt, I add viridian to the color and apply it in broken brushstrokes to create a blending between the dirt in shadow and the foliage. I am not concerned about losing the fence here, although I do keep the dark area at the bottom of the canvas, which will become the bottom edge of the fence.

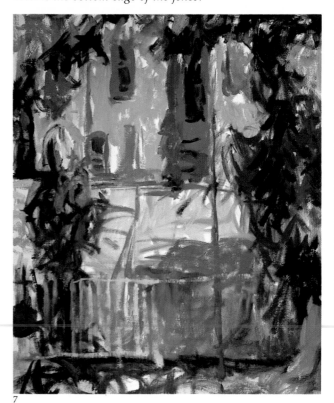

7

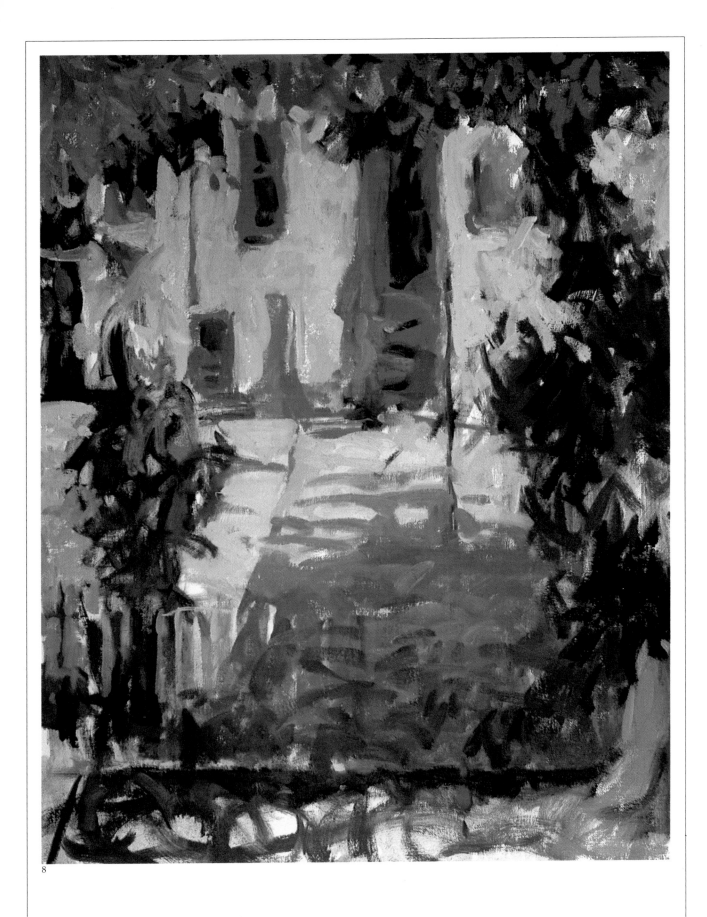

8

Pull It Together

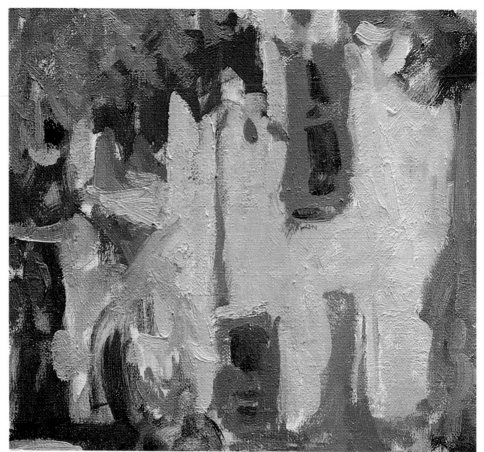

8 (detail)

Step 8 (Detail)
In this detail from step 8, you can see that my brushstrokes are still imprecise. I am simply putting paint on the canvas in an attempt to get closer to the correct colors of the foliage and buildings. It is a stage during which major decisions are made.

9 (detail)

Step 9 (Detail)
Once I'm satisfied with my decisions, I start to use specific brushes to get the kind of impasto and brushwork I want for the various objects in the painting. Essentially it is a matter of repeating what was done in the last step, but being a little more careful about the abstract shapes and color relationships. Almost all my paintings are started with a loose technique. For a more controlled look, I just carry the painting several steps further. The great changes in the appearance of the canvas usually occur in the early stages. From then on, the changes become more subtle.

Step 9

At this point I begin to pull the whole picture together. Many of the colors are re-stated, and I begin to suggest the character of the leaves wth a no. 1 round bristle brush. (In the final step I will restate the foliage, using a no. 1 round bristle brush for the large leaves but small round sable brushes for the small leaves.) I also introduce stronger color to the building, but then decide the chroma is too strong and correct this in the next step.

Notice that the fence has almost completely disappeared. I paint the bush and ground behind the fence and wait for this to dry before repainting the fence. The foliage color varies from viridian with ultramarine blue for the darks to viridian and chromium oxide green for the middle values. Where the foliage is light, I add yellow ocher or cadmium yellow light to the viridian and white. I also try to get a color temperature change from green to blue in the darks.

9

Step 10

Once everything seems correct I roughly indicate the fence and clothesline. I mix a middle-value gray, add a little cerulean blue to it, and with a no. 1 round sable brush, indicate the positions of the pickets on the fence. The clothesline and clothes are laid in with titanium white, painted right over the wet fence. In preparation for the next step, I squeeze my paint onto a blotter to absorb some of the oil, so that the paint will hold the impasto effect I intend to create.

10

Add the Finishing Touches

11 (detail)

11 (detail)

Step 11 (Detail—Top Left)

In this last step it is simply a matter of repeating colors and applying them in a way that creates the exact look I want. With the darks of the bush established, I mix two or three lighter values of the green, adding more cadmium yellow for the lightest green. I apply pieces of this green pigment with a no. 1 or no. 0 watercolor brush. The lightest greens are put on last, with the wet paint laid on the canvas without any brushing. In fact, at the end, almost all the pigment is applied in this way; bits of paint are literally laid one on top of another.

For the gray of the fence shadow, I choose a mixture of black and white. At various points I add cerulean blue, viridian, or alizarin crimson to this gray. The light areas of the fence are a mixture of white, yellow ocher, and cadmium yellow light. Again, all the paint is applied in a heavy impasto. Once it is all down, I "push" the paint around a little for subtle effects. As a last touch, I put in the green foliage on the fence, working wet on wet.

Step 11 (Detail—Top Right)

To capture the feeling of the clothes blowing in the wind, I first study the action for a while. Then, quickly but carefully, I place paint over the areas of clothes that I roughly indicated in the last step. I'm lucky and get a feeling of movement in the clothes, so I apply thicker white paint with a touch of yellow ocher. Once this nice, juicy wet paint is in place, I mix several small piles of paint:

white with cerulean blue, white with cadmium yellow light, white with viridian, and white with alizarin crimson. With a no. 1 or no. 0 round bristle brush, I carefully apply each color to a different section of the clothes. Then I "push" the colors together, taking care not to lose each distinct color. If the paint flattens too much, I pile on lots more paint. I indicate light and dark spots on the clothesline and pole to create the effect of sunlight between the leaves. Finally I add the red and blue clothes, and the painting is complete.

Step 11 (Finished Painting)

Although, with the previous step, all the problems have been solved, in this final step many parts of the canvas are repainted. Once I have established the final color, I remix that color and rework that area with different brushes to get the character of the different leaves with the kind of impasto I desire. If there is too much impasto, I scrape down the area with a palette knife.

For the light leaves at the upper right, I use a no. 1 round bristle brush, while I put in the long, dark leaves with a no. 5 round sable. The bush in the middle left and the flowers in the lower left are painted with a no. 1 round sable watercolor brush in an almost pointillist technique. All the red flowers are painted wet on the wet green. Then, after everything is dry, I add a final coat of Winton picture varnish.

Backyard, *oil on canvas, 20″ × 16″ (50.8 × 40.6 cm)*

This "gallery" of my paintings spans a variety of techniques, from more controlled to fairly loose. In each case, the method was determined by my inclination at the time and the subject to be painted. I do not mean that a particular subject should be painted in a specific manner. On the contrary, with the exception of commissioned portraits, I let intuition be my main guide.

Even when a controlled look is desired, there are several ways of arriving at a solution. One method is to start with an accurate, detailed drawing and stay within its guidelines throughout the painting. A second method—the one I prefer—is to start in a loose, sketchy manner and then slowly pull the painting together until the desired degree of finish is achieved. Control of both methods should be in your repertoire so that the choice is really yours.

Using a Controlled Technique

This painting was carefully planned. From the moment I saw the enamel and copper jardiniere, I wanted to paint it. I set up the still life with an eye to the interplay of color. The solid blue drapery, of course, establishes the main color theme. But notice how the striped wall covering in the back provides a soft echo for the colors of the pot, while the mid-Eastern tile calls attention to the intricate patterning. I spent days rearranging the composition until it looked just right. At one point I decided there were too many big, solid shapes, so I added the delicate touch of the twigs and small buds.

Painting the picture itself was a slow, tedious process—it took me about six months. As you can see, there's a high degree of finish, with careful attention to the different textures.

Composition Blue
oil on canvas
30" × 24" (76.2 × 61 cm)
recipient of the Newington Award,
American Artists Professional
League Grand National
Exhibition 1981

To prevent the tile from competing with the jardiniere, I kept its chroma on the weak side. Careful placement of the highlights gave it the correct form.

The warm color on the buds pulls them away from the very strong chroma of the cool blue drapery.

This is the warmest spot in the painting and thus attracts the viewer's eye. To make it look like hammered copper, I indicated the change in value and chroma, using burnt umber, burnt sienna, and orange. On the right rim, I added a reflection of the blue drapery.

The various sections of the jardiniere were first painted in flat, solid colors to get the correct value and chroma. Then I remixed each color in all its variations and carefully repainted each area, blending all the connecting edges.

Even details like these Arabic letters are important. The perspective had to be correct to show the pot's form.

A Study of Textures

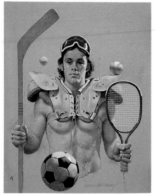

Young Athlete
pastel on stretched paper
40" × 34" (101.6 × 86.4 cm)
recipient of the Andrew Nelson
Whitehead Award,
Pastel Society of America
Exhibition 1981

One day my son Richard walked through my studio wearing his football shoulder padding. The abstract shapes looked beautiful, and the idea for this pastel painting was born. Richard, however, soon became bored with posing, so his friend Billy Boshell took his place.

As I worked on the composition, I decided to include other sports to make the painting more universal. For lighting, I chose a soft form lighting with a strong, high-positioned rim light. This helps to make the head more dramatic, so that it remains the center of interest.

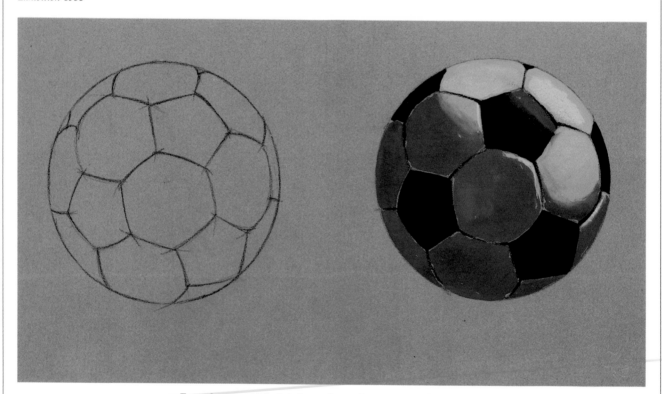

For a large pastel, it helps to keep the amount of pastel applied to the paper to a minimum. On this soccer ball you can see how to establish the values by using watercolor. After making a careful drawing, paint the darks a solid black and the lights a correct value of gray. When the paint is dry, continue with pastels. Take special care to place the abstract patterns of the ball in the correct positions.

To achieve the look of plastic or glass, I made all the edges here crisp and hard. The face, in contrast, is soft, with the hair to the sides even softer.

This baseball has a main light and a reflected light. I made the edges weaker in chroma and the half-tone warmer to help round the ball.

Making the hockey stick large in relation to the model brings it forward and pushes the figure back.

The sculptural feeling of the shoulder pads depends on the interplay of hard edges coming forward and softer edges receding.

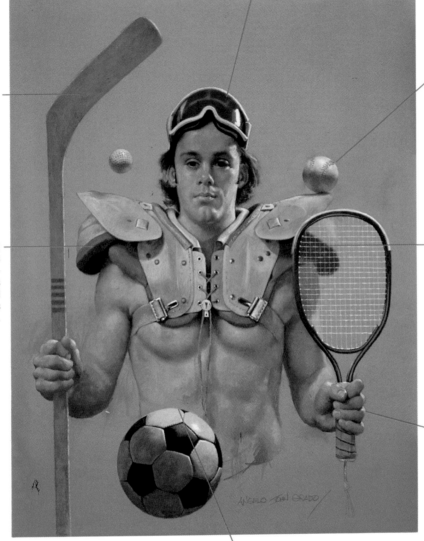

The lighter value of the shoulder pad's underplane here gives a forward thrust to the racket strings. The harder edges and stronger chroma of the strings also help to project the strings.

The hands had to show strength and character. I spent time studying small details like the fingernails and the shape of all the knuckles. I put dark accents where the rim lighting hit the knuckles and strengthened their chroma by adding red.

To create a feeling of space between the soccer ball and the model, I made the top edge of the ball harder and stronger in chroma than the figure. The change in color temperature in both the lights and the darks makes the ball seem more real.

Different Techniques with the Figure

This loosely painted picture is one of my personal favorites, perhaps because of its simplicity. I applied the paint fairly smoothly on the background, somewhat more broadly on the figure, and quite broadly on the shawl. All the lines lead up to the head, which is the center of interest.

The prevailing grayish color is made with raw umber. Once I established the value of the raw umber, I put in the other hues—but I kept the values the same. In fact, most of the colors are this value. I did, however, subtly grade the background, making the value slightly lighter at the top. I also made the color warmer near the top.

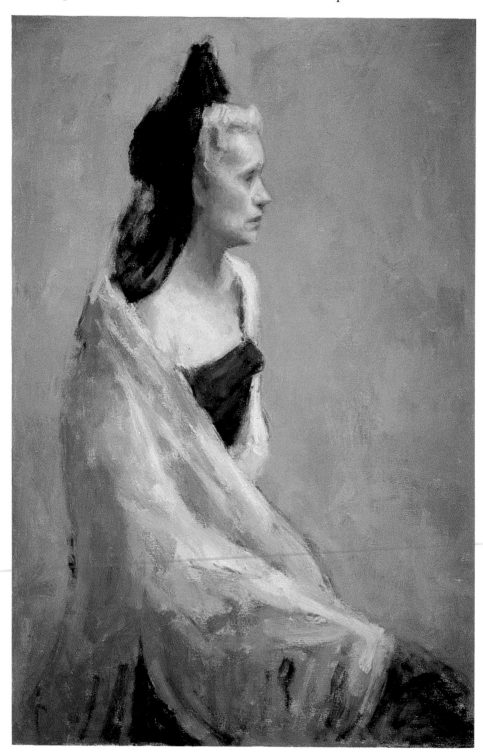

Lady with Black Hat
oil on canvas
30″ × 20″ (76.2 × 50.8 cm)

For the oil painting here, I gave the canvas a weak-chroma underpainting to simulate a pastel paper. The model's complexion is a medium chroma, with the chroma becoming stronger on the face and strongest in the chest area. I kept the background sketchy and only briefly indicated the various things behind the model.

After completing the oil painting, I decided to paint a pastel using the same model and pose. Everything in the pastel is softer and lighter, and the colors are more luminous. To get the effect I wanted, I varied the color temperatures. Note particularly the blue in the chest area and the blues and greens on the legs.

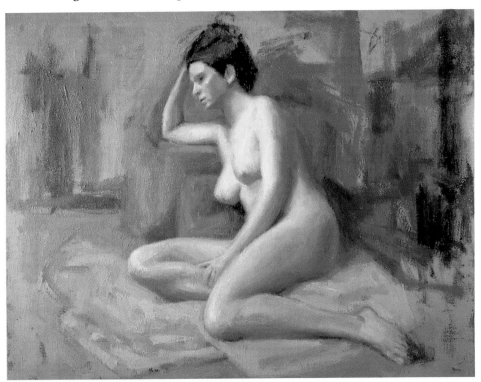

Figure Study
oil on panel
16″ × 20″ (40.6 × 50.8)

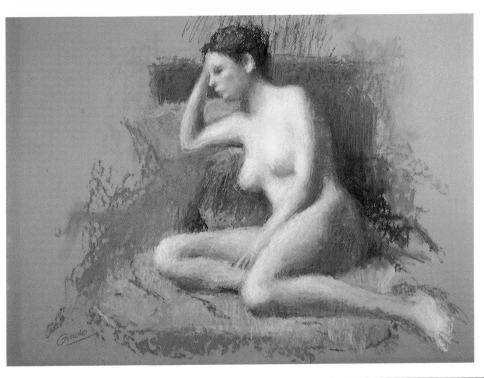

Figure Study
pastel on paper
17″ × 23″ (43.2 × 58. cm)

Painting with Texture

Here my model had a delicate quality and I decided to paint her as simply as possible. I used a minimum of color with very subtle changes in chroma. As you can see, you don't need a lot of color to make an effective statement.

For this painting I used one of my favorite methods. It's a lot of fun to do. First I give the canvas an underpainting of a weak-chroma burnt sienna and allow it to dry. The final colors are then roughly painted over this. What the underpainting does is to give a soft unity to the whole.

Lady with White Hat
oil on canvas
20" × 16" (50.8 × 40.6 cm)

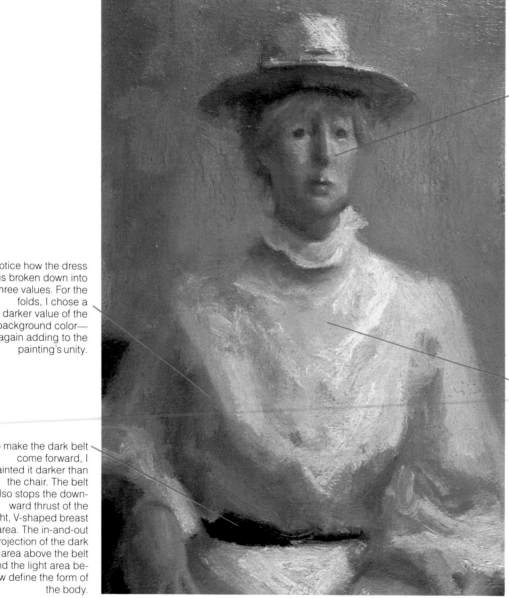

The concentration of warm color is in the face. By softening the edges at the back of the head and the ends of the hat's brim, I made the face and the light on top of the head the main centers of interest. To keep the simplicity I wanted, I avoided detailed features—merely suggesting the eyes, nose, and mouth.

Notice how the dress is broken down into three values. For the folds, I chose a darker value of the background color—again adding to the painting's unity.

To get the feeling of flesh showing through the gown, I added a little of my flesh color to the color of the gown.

To make the dark belt come forward, I painted it darker than the chair. The belt also stops the downward thrust of the light, V-shaped breast area. The in-and-out projection of the dark area above the belt and the light area below define the form of the body.

This painting was done in three hours. It's a good way to get down to essentials. I scheduled my time to allow twenty minutes for each eye and twenty minutes for the mouth—important features in conveying character.

For this painting I used an old canvas and painted directly over the old picture. At points I even let some of the old background show through. The main center of interest, however, is clearly the face.

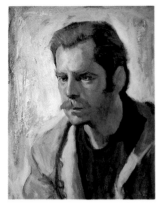

Young Man with Moustache
oil on canvas
18" × 14" (45.7 × 35.6 cm)

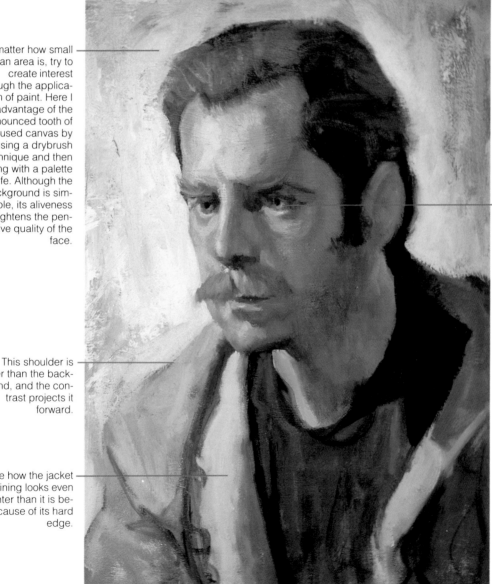

No matter how small an area is, try to create interest through the application of paint. Here I took advantage of the pronounced tooth of the used canvas by using a drybrush technique and then working with a palette knife. Although the background is simple, its aliveness heightens the pensive quality of the face.

I put just enough light on the eye to the right for the light to catch and light up the iris of that eye. If you look closely here, you can see that although the details are painted in a broad manner, everything important is indicated.

This shoulder is darker than the background, and the contrast projects it forward.

Notice how the jacket lining looks even lighter than it is because of its hard edge.

Textures in Pastel

The Little Mother
pastel on stretched paper
24" × 20 " (61 × 50.8 cm)
recipient of Best Portrait Award,
Pastel Society of America
Exhibition 1978
collection of Megan Devir

Originally I tried to get Megan, one of my eight grandchildren, to pose for a more formal portrait, but she was uncooperative. She finally agreed to play-act and posed as a mother with her child. In painting children, it helps to get them involved by using fantasy.

All my paintings are really studies in texture. Here the texture of the drapery, the girl's face, and the doll's head had to be carefully controlled. The loose handling of the drapery conveys its roughness. For the girl's head, which is smoother, I used a tighter technique.

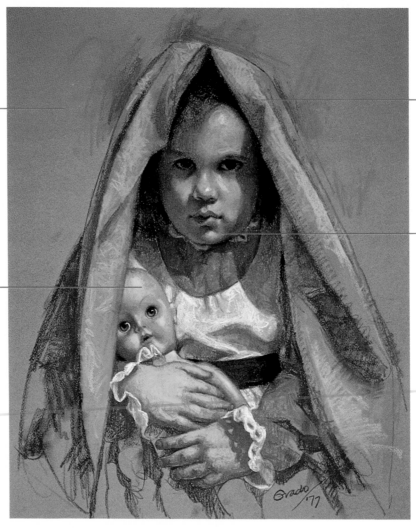

I almost always use the paper as the background color, but I introduce other, weak-chroma colors so that it does not look too flat.

The doll's head is the smoothest, shiniest object in the painting. To get this effect, I closed up my pastel strokes, used my finger to smooth the surface a little, and made the edges and highlight somewhat hard.

In painting drapery with pastels, the calligraphy is very important. The direction of the pastel strokes should be varied as much as possible.

The round shape of the chin is repeated in the round shape of the dress and then reversed in the round shape of the doll's head.

For this large pastel portrait, I added a second figure in the background to fill out the area behind the standing child. This second figure then set the mood for the background, where the colors give the painting a feeling of fantasy.

Creating a sense of space was important here. The girl and her doll had white dresses, but I added warm color to the doll's dress and carefully positioned its overlapped folds to make it project. Then, by adding blue and green to the girl's white stockings, I made her legs recede, so that her dress, too, projects.

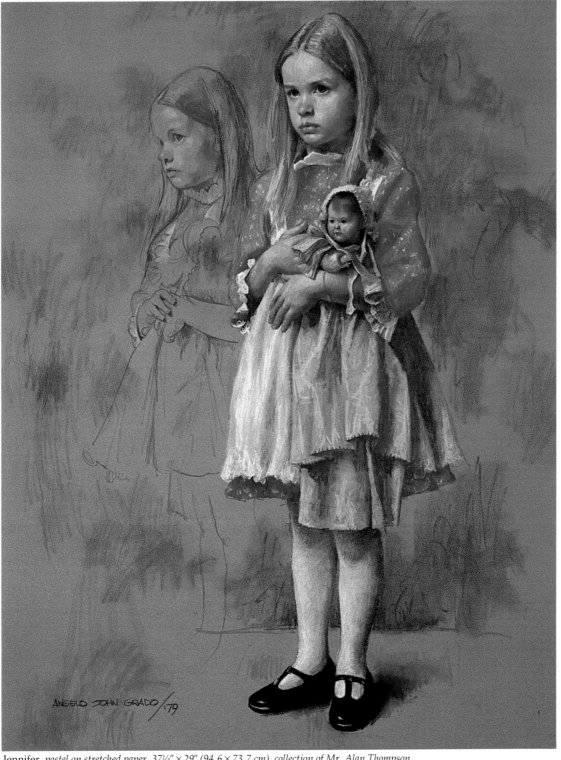

Jennifer, *pastel on stretched paper, 37¼″ × 29″ (94.6 × 73.7 cm), collection of Mr. Alan Thompson.*

Making Flesh Luminous

One of the most challenging tasks in painting nudes is to get the luminosity of the human flesh in the light, especially when the model has a very light skin. Here I used the texture of the background as a contrast to the flesh. To give the skin its iridescent quality, I concentrated on the interplay of changes in color temperature. Notice, by the way, how the whole composition is structured on a triangle, which is repeated in the head.

Because the center of interest is the lower section of the figure, the head and and upper background have thin paint and soft edges.

The straight line here stabilizes the diagonal thrust of the drapery and the arm on the left side of the canvas.

This straight arm along with the straight drape counteracts the busyness of the figure on the left side. The straight arm also emphasizes the curve of the hip and leg.

This dark area of the drapery helps to bring out the model's legs. Observe how this thigh shows tension because of the pressure of leaning on the seat, while the thigh to the right is more relaxed.

This section of the hips and upper thigh is painted with a heavier impasto. After building up the impasto, I intermingled cool and warm colors, using almost a drybrush technique.

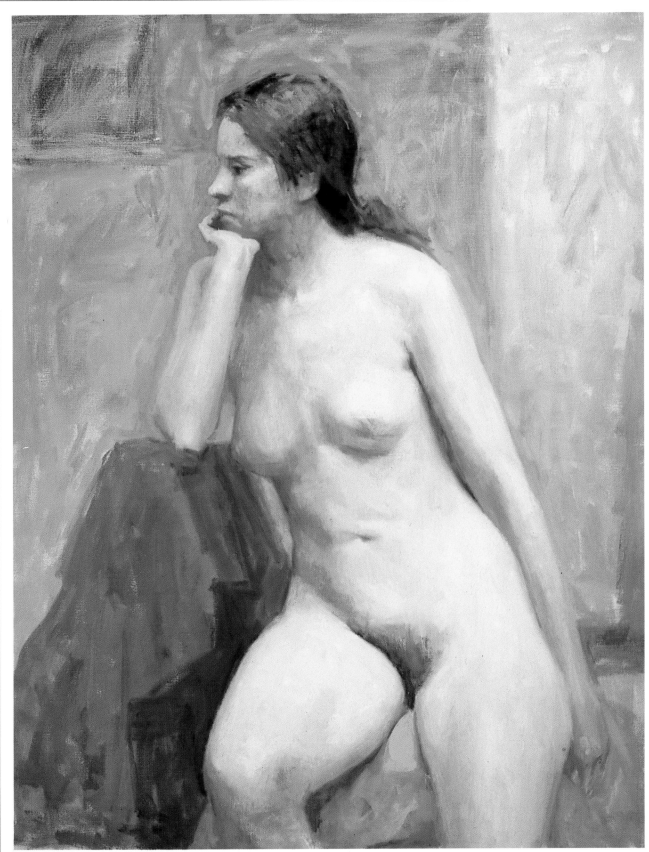

Model in Thought
oil on canvas, 38" × 30" (96.5 × 76.2cm)
recipient of a bronze medal from the National Academy

Texture in Still Lifes

The Sea Shell
oil on panel
9″ × 12″ (22.9 × 30.5 cm)

A small painting like this one offers the joy of concentrating on one or two objects. The challenge was to make this simple subject work as a painting and to capture the iridescent colors in the smooth part of the shell.

I used three basic values—one in the light, one on the shell's main body, and one on its dark front—and interplayed warm and cool colors. Notice where I put green next to orange, red and orange next to red-purple, and gray-green next to burnt sienna. You can also see three degrees of edges. Because the top of the shell is very thin, the edge is hard. The body is round so it has a softer edges. The underplane, which is in the shadow, has the softest edge.

The top is made interesting by subtle changes in its color and edges.

The background is painted with variations of burnt sienna and viridian.

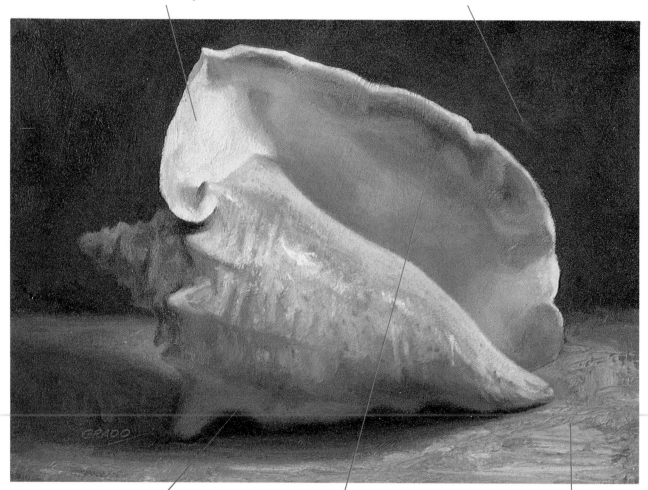

All the underplane edges are soft.

To get the iridescent look here, I used red-purple, yellow-green, green, and a luminous color mixed from red-purple and orange.

The texture of the table, painted with a palette knife, contrasts with the shell.

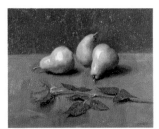

Three Pears
oil on panel
16″ × 20″ (40.6 × 50.8 cm)
collection of Mr. James R. Dawley

Here I positioned the pears to give as much action as possible to the composition. It would have been boring if they had all pointed in the same direction.

As the background moves to the right, it becomes lighter in value and warmer (from more green to more burnt sienna).

Because wet red and green do not mix well, I let the green pears dry before adding a light orange color. I then painted the red into the center of the wet light orange.

As the edge of the table meets the pears, it becomes softer. The hard edge of the fruit then projects the pear forward.

The handling of the shadows here creates a feeling of three dimensions. When the stem and table are close, the shadow is darker; when the stem moves away from the table, the shadow is lighter. The shadow under the rose is darkest because it is the biggest shape and lies directly on the table.

Focus on Facial Features

My father was born in Sicily, so I wanted to paint him in warm Mediterranean colors. The forms are built with a series of small pastel strokes, left open in many places. I wanted a loose, casual feeling so areas like the shirt, ear, and hair are only barely indicated. Cool colors are intermingled with warm colors for a change in color temperature.

My wife's father—Frank Johnson—had distinctive features and a strong bone structure, making him a good subject for a portrait. To make his forehead more solid, I varied the edges, with the hardest section facing the light source. With the back of the head, I started with a hard edge on top and softened it by running my finger along the edge as I moved down. All this helps to project the head. At the bottom, around the collar, I used soft, broken edges to give further emphasis to the head.

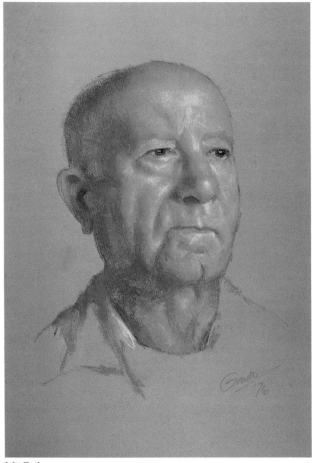

My Father
pastel on paper
17" × 14" (43.2 × 35.6 cm)
collection of the artist

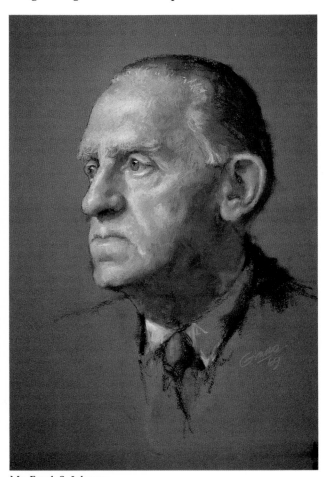

Mr. Frank S. Johnson
pastel on paper
17" × 14" (43.2 × 35.6 cm)
collection of
Justine Barbara Grado

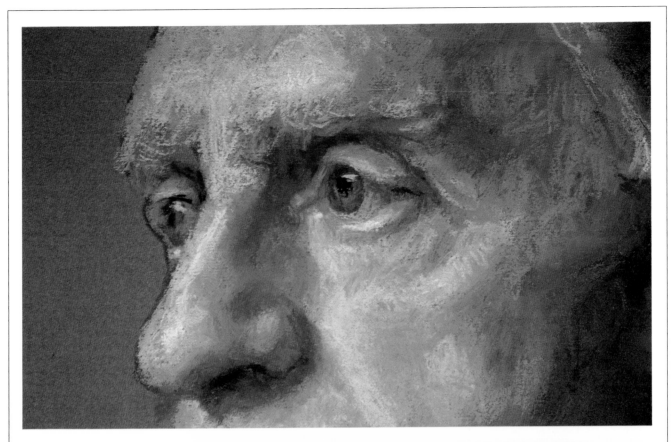

The combination of large eyes and eyelids with the strong bone structure of the nose made this area easy to paint. To give the dark shadow areas greater vibrancy I added a middle-chroma red, in the same value as the shadows. This red was also added to the rims of the eyes. Always make sure that the highlight of the eyelid is above the highlight of the iris.

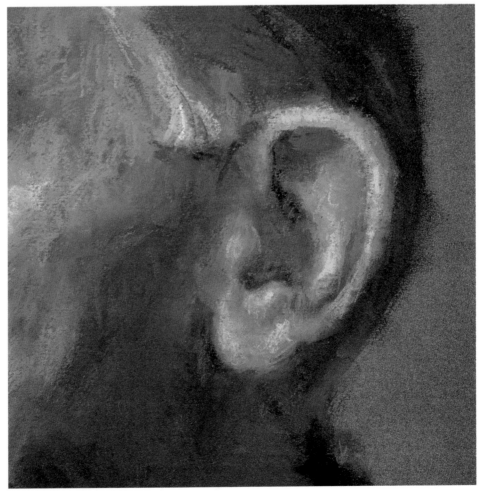

The value changes on this ear are created by changes in hue. Notice how the chroma of the hues weakens as they move into the shadow. To project the back edge of the ear, I used a stronger chroma on the ear itself and softened the edge of the hair. Throughout, I kept my pastel strokes small and paid special attention to the placement of the highlights.

Pastel Portraits

My Son Frank
pastel on stretched paper
18" × 24" (45.7 × 61 cm)
collection of Mr. and
Mrs. Frank Grado

This is my son Frank during his hippie days. As an artist, I thought he was very paintable. But as his father, I wished he would shave and cut his hair. In any case he was fun to paint.

The three heads here are almost a demonstration of my procedure for painting a head in pastel. Most of my pastels begin with sketchy strokes, progressing to the degree of finish I want. At any stage the head can be stopped and considered complete.

Together, the tops of the three heads form a smooth edge compared with the jagged, vignetted edges at the bottom.

To make this center head as strong as possible, I used bold color, vigorous pastel strokes, and strong highlights in the eyes. Observe how the iris opposite the highlight picks up a little light from the highlight.

Note how some of the paper shows through the pastel strokes.

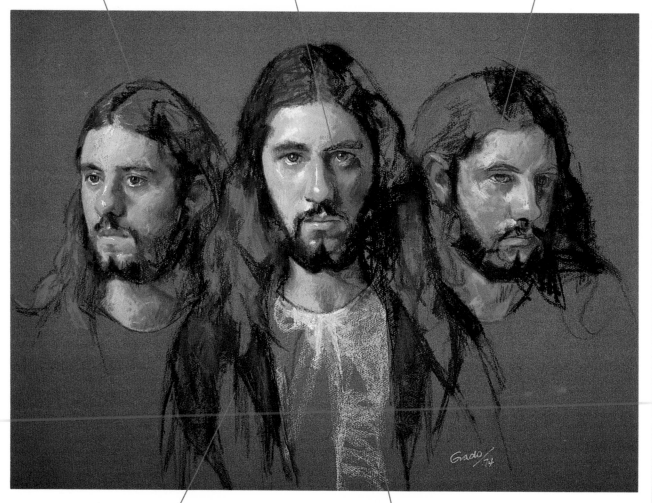

In vignetting an edge, try to make the shapes abstractly interesting.

The calligraphy of the pastel strokes here is different from the strokes on the green cape.

At the time of this portrait I had just completed some complicated paintings and wanted to paint something with less detail. My son John was elected to pose. I chose a dark pastel paper and stretched it on a piece of Masonite. Using only one color—a dark brown pastel—I made a drawing. Once this drawing was complete, I slowly added color to the face, as well as black for the accents. The feeling of the figure emerging from the background color gives the picture an air of mystery.

My Son John
pastel on stretched paper
23" × 17" (58.4 × 43.2 cm)
recipient of Best Portrait Award,
American Artists Professional League
Grand National Exhibition 1973
collection of Mr. and
Mrs. John Grado

In this closeup of the face you can see how some areas have no complexion color. In contrast, I built up the light areas with stronger color and thicker application of the pastel. I added some red to the lips and cheeks, and then used this red to indicate the shirt color. I took care, however, not to overdo the color on the shirt.

Working Loosely

Except for portrait commissions (which require a high degree of finish), this is the way most of my paintings look at the beginning. Once the composition is established, I roughly indicate all the features, carefully separating the lights from the shadows.

Here the underpainting of raw sienna shows through between the brushstrokes of blue and keeps the background color from becoming too cool.

The face is painted with lost and found edges, and with the features barely indicated. Everything in the shadows has what is almost a "big blur" edge.

The edges on the back of the head go from hard to very soft.

Because the bottom of this headband has the hardest edge, it brings the viewer's eye to the forehead and the face.

The brightest part of the red scarf is between the light shoulder and the light on the neck. This brings you to the front edge of the neck and then to the stronger edge of the chin.

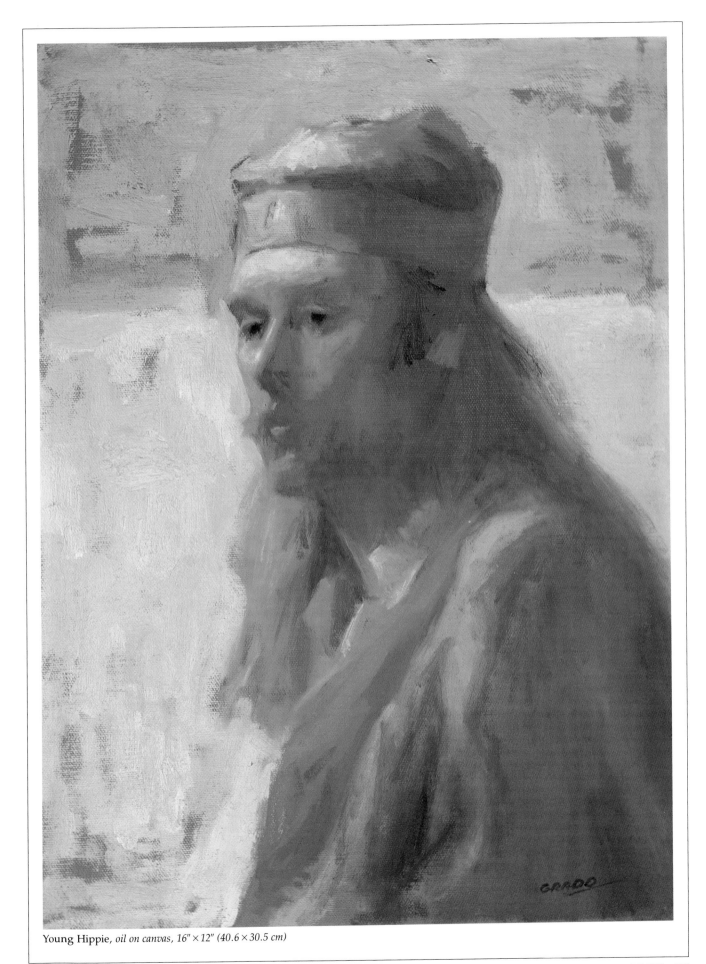

Young Hippie, *oil on canvas, 16″×12″ (40.6×30.5 cm)*

Creating Interest

In painting I like to set up challenges for myself. Here the problem was to capture the textures of the various objects.

Still Life with Milk Can
oil on panel
20" × 24" (50.8 × 61 cm)

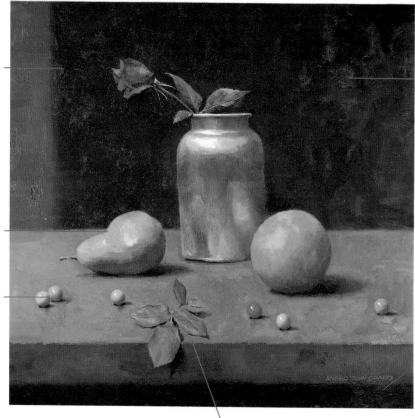

This soft, vertical edge directs the eye to the harder edge of the rose and from there to the even harder edge of the milk can.

The edges of the pear are hardest at the point where they face the light source.

Because the marbles are made of glass, they have very bright, hard highlights.

For the background I first did an underpainting in burnt sienna and let it dry. Then I scumbled raw umber and burnt umber over it and painted green into some sections, wet on wet.

The bottom edge of the table is soft, while the upper front edge is hard, bringing the eye into the picture. After the table was dry, I added the rose leaves, which lead the eye to the milk can.

The first thing to notice in this painting is the axis of each onion. The varied directions of the onions add interest and movement to the composition. The top lighting also creates interest by giving a specific shape to each shadow.

For the shadows I used a dark-value, weak-chroma burnt sienna and added touches of the same-value green. The netted sack was painted directly, with almost no blending. On the right I simply laid the net color on top of the wet onion color. When painting on wet paint, just "place" the new paint on the wet paint and then don't disturb it.

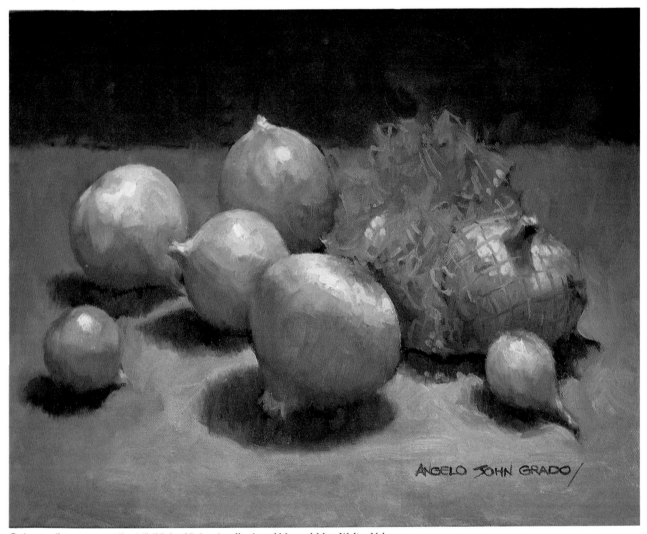

Onions, *oil on canvas, 11" × 14" (27.9 × 35.6 cm), collection of Mr. and Mrs. Walter Nelson*

Telling a Story In painting an interior like this one, I always try to think of a story for the painting, which gives it a focus. The open letter and single rose on the desk create a feeling of mystery, while the lit-up but empty chair adds drama. The title—*Love Lost*—suggests the story I imagined.

The reflections and shadows of these two wall lights cross each other and form interesting patterns. Notice how the smaller opening at the top allows less light to shine on the wall than the larger opening at the bottom does.

The hall, which is lit with an overhead light, has the lightest value, but its weak chroma keeps the color outside the room.

The cast shadow of the picture frame helps make the scene more dramatic. It's like an explosion on the wall, and it contrasts with the straight shadow line of the door on the opposite wall.

To make for more interest in the shadow, I let the top of the teapot catch the light. Without the teapot, the picture on the wall would be too isolated. Try, whenever possible, to interlock as many shapes as you can.

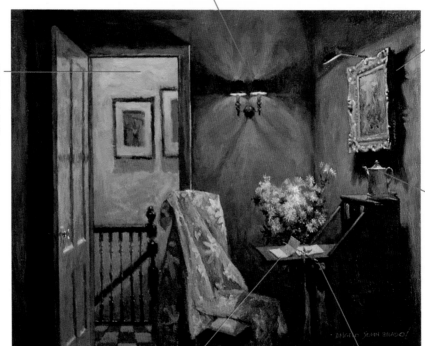

Because the two sheets from the letter have the hardest edges in the painting, they stand out. Look for the change in value, hue, and chroma in the folds of the top sheet.

To make the rose important, I painted it in the dark area under the open desk.

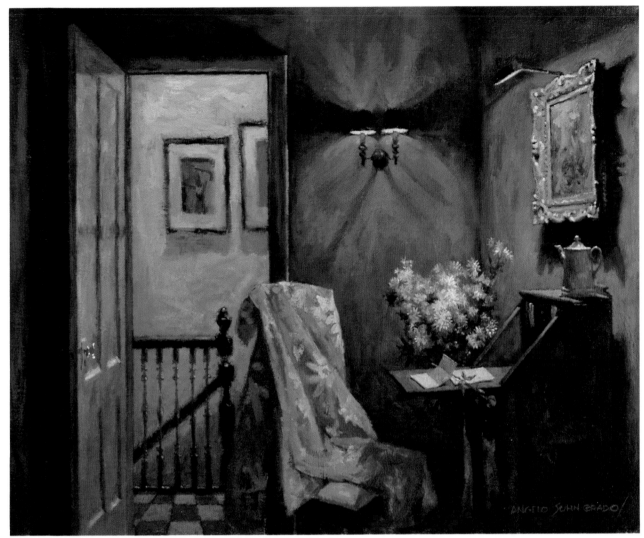

Love Lost, *oil on canvas, 16" × 20" (40.6 × 50.8 cm), collection of Mr. John Jacome*

Index

Concept and structure by Bonnie Silverstein
Designed by Bob Fillie
Graphic production by Hector Campbell
Text set in 11-point Palatino